IMAGES
of America

HOLLY SPRINGS

IMAGES
of America

HOLLY SPRINGS

Alice Long and Mark L. Ridge

ARCADIA

Published by Arcadia Publishing
Charleston SC, Chicago IL, Portsmouth NH, San Francisco CA

Printed in the United States of America

Library of Congress Catalog Card Number: 2005934206

For all general information contact Arcadia Publishing at:
Telephone 843-853-2070
Fax 843-853-0044
E-mail sales@arcadiapublishing.com
For customer service and orders:
Toll-Free 1-888-313-2665

Visit us on the Internet at www.arcadiapublishing.com

CONTENTS

ACKNOWLEDGMENTS

Many special residents of Holly Springs have helped us in collecting and documenting the photographs we have included in this book. First among them is the Reverend Milton Winter, pastor of Holly Springs's First Presbyterian Church. Our most cordial thanks are due to David Person, Lois Swaney, David L. Beckley, Ishmell Edwards, Anita Moore, Ann Reed, Lanier Robison, Chelius Carter, Al Hale, Jack and Betty Werne, Jorja Lynn, the Reverend Bruce McMillan, Edward Rather, Marie Rather McClatchy, Bea Green, and Katherine and Joyce Delashmit. Special thanks go to the Miller family, whose ancestor appears on this book's cover and whose sharing of photographs is greatly appreciated, and to Claiborne Rowan Thompson and Kay Thompson Wheeler, whose graciousness has welcomed us to their kitchen's "round table" countless times and whose generosity and good humor have made the production of this book pleasurable and memorable.

One individual has been an outstanding source of energy, effort, and dedication throughout this project. Laura Ashley Wheeler deserves far more thanks and credit than can be expressed here. Without her kindness and tirelessness, this book would have been impossible. Laura Wheeler is, indeed, one of the most beautiful people I have ever been fortunate enough to call my friend.

This book is dedicated to Laura. It is also dedicated to Carolyn McCrosky, James Houston "Rooster" Miller, Jerry Delashmit, Mary Lynn Brown, Fonta O'Dell, and Mae Alice Booker, affectionately known as "Mae Mae," whose passings this year have saddened Holly Springs. And especially, this book is dedicated to Claiborne Rowan Thompson, who died on Christmas Eve, 2005. All of these people have enriched this small city. All of them have left behind wonderful stories that will never die.

INTRODUCTION

The city of Holly Springs, Mississippi, began as European Americans and African Americans moved from Virginia and the Carolinas to settle the Mississippi land obtained from the Chickasaw Indian Land Cession of 1832. To this day, many homes in Holly Springs date from the 1830s, and some still have parts of their original log walls inside a closet or serving as interior walls. Some homes that were built as log cabins were razed and rebuilt in a more commodious style or made more elaborate with clapboard and wood flooring. Some residents also live in relatively modern structures on land their ancestors purchased in the 1830s during the Chickasaw Cession.

The settlement that became Holly Springs got its name from natural groundwater springs that were surrounded by holly. Native Americans knew of and used these springs, and a beautiful walking trail now winds through the area of the original holly springs. "Springs" or "Spring" Street runs north and south beside this area, although most people have forgotten the quite literal source of the name.

The coming of rail access and the prosperity of Holly Springs's antebellum slave and cotton economics led to the 1850s construction of many larger and grander homes, including Gray Gables, Airliewood (formerly known as Coxe Place), Walter Place, Montrose, Fleur de Lis, and the Fort-Daniels House (formerly known as Craft Place). This book features some of these homes and the families that built or bought them, along with other structures that survived the War Between the States, including our Presbyterian church, which is still scarred from minie balls and shrapnel. Homes, if not families, survived the horrendous yellow fever epidemic of 1878; on quiet, hot summer nights, one can feel to this day the stillness and dread of that terrible time that saw streets emptied of traffic, homes and even the courthouse turned into hospitals, and families burying their dead in Holly Springs's Hill Crest Cemetery. In some cases, structures have clung to life through the devastation of financial decline and decades of neglect.

Today Holly Springs boasts numerous homes that have been lovingly restored to grandeur. Besides residences, the city's town square features antebellum storefronts and offices that have seen the many changes—good and ill—of the 19th, 20th, and 21st centuries. For more than 60 years, our annual Spring Pilgrimage, the Holly Springs tour of historic homes, has been the city's most popular attraction.

It is the life of Holly Springs from the post-war 19th century through the 20th century that this book focuses on most closely. These photographs tell stories of their own and are taken from collections that, for the most part, have never before been published.

Images of America: *Holly Springs* gives readers an authentic glimpse into Holly Springs's life, which continues to flourish at such town square landmarks as the City Café, Linwood's Clothing Store, and Tyson Drugstore, as well as in the homes of Holly Springs's residents, many of whom are descended from those early pioneers who dared to head west to brave the North Mississippi wilderness.

Join us as we take you on a pictorial tour of one of the quaintest cities in the American South. Movies such as director Robert Altman's *Cookie's Fortune*, filmed here in the late 1990s, give viewers an excellent perspective of Holly Springs as a location. What we are offering in Images of America: *Holly Springs* is a genuine insight into Holly Springs as home.

One

MEMENTOES OF THE 19TH AND EARLY 20TH CENTURIES

Few specimens from Holly Springs's earliest photographic record are extant. Perhaps the trials and troubles of the Civil War, during which the city changed hands over 60 times, discouraged photography. As one descendant of an old Holly Springs family puts it, residents had to look out the window each morning to see which flag was flying in order to determine whether Union or Confederate forces controlled the city. The yellow fever epidemic of 1878 yielded few photographs of that dreadful time, which no one wanted to remember; instead, Holly Springs's Hill Crest Cemetery is dotted with markers commemorating those who died in September and October 1878. As the century of war and plague gave way to a new century's beginning, photography became more desirable.

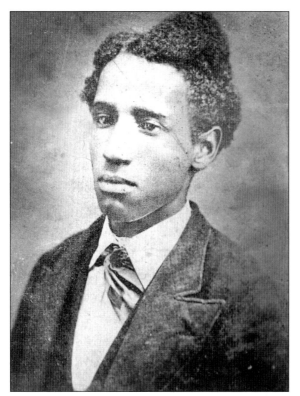

ROBERT Q. ADAMS, RUST COLLEGE, CLASS OF 1878. This gentleman was one of only two members of Rust's first graduating class. In 1878, the worst yellow fever epidemic in this area's history struck Holly Springs, Mississippi. Earlier epidemics, especially in nearby Memphis, Tennessee, had not affected African Americans. However, the plague of 1878 sickened and killed blacks and whites alike. (Courtesy of Anita Moore and the Rust College Archives.)

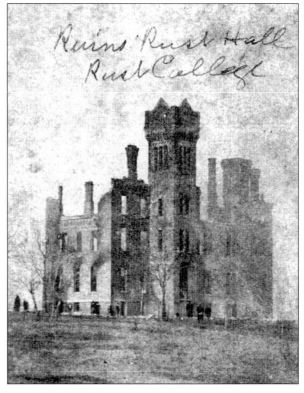

"RUINS RUST HALL, RUST COLLEGE," 1892. This sepia photograph was given to current Rust College president Dr. David L. Beckley. As its inscription tells us, this structure was an early building named Rust Hall that burned in the 1890s. Another Rust Hall, built between 1897 and 1909, burned in 1940 and was replaced by the McCoy Administration Building, which stands today. (Courtesy of David L. Beckley, Anita Moore, and the Rust College Archives.)

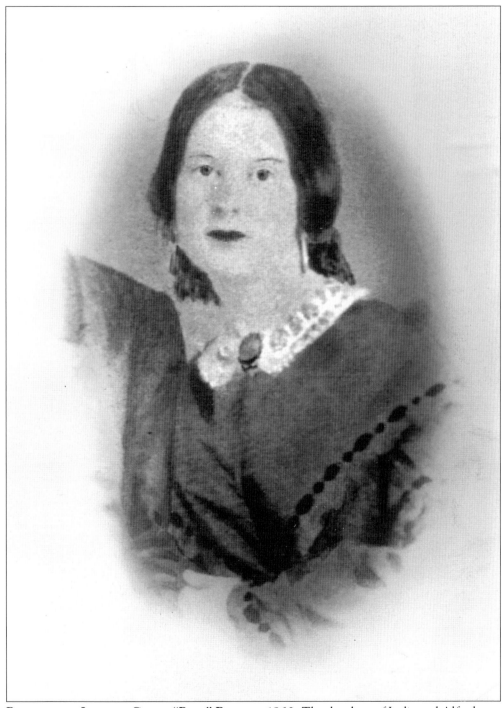

PORTRAIT OF LOUANN GREEN "PUSS" BROOKS, 1860. The daughter of Lydia and Alfred Brooks, Puss was born March 28, 1843. She married James C. Robison on July 18, 1861, and died May 14, 1867, possibly in childbirth. She was the grandmother of Holly Springs banker Lanier Robison. (Courtesy of Lanier Robison.)

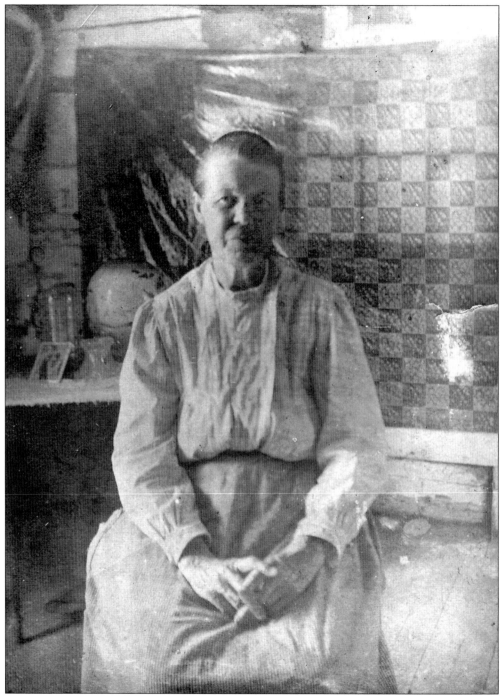

AN UNIDENTIFIED ANCESTOR OF HOLLY SPRINGS'S REV. MARSHALL DELASHMIT. Although her identity remains a mystery, the lady and her surroundings tell a story of their own. The Reverend Marshall Delashmit was pastor of Chewalla Assembly of God for more than two decades and managed local Lunati Farm from 1960 until 1973. The farm provided work for many Holly Springs residents during the Great Depression.(Courtesy of Katherine and Joyce Delashmit.)

AN 1855 INVITATION TO A COTILLION IN NEARBY WATERFORD, MISSISSIPPI. This quaint, handwritten invitation from the private collection of Lanier Robison expresses the courtesy and panache of the Old South. (Courtesy of Lanier Robison.)

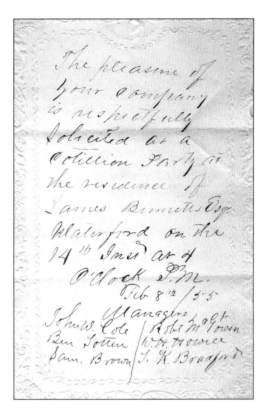

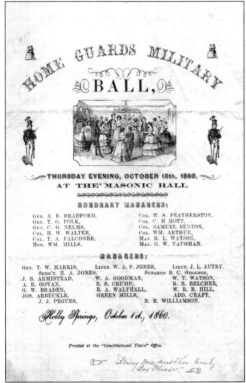

AN 1860 ANNOUNCEMENT FOR THE HOME GUARDS MILITARY BALL. Imagine the festivities at this mid-October soiree hosted during the last autumn before the horrors of the Civil War. Prominent Holly Springs names, such as Polk, Walter, Falconer, Featherstone, Mott, Govan, Crump, Walthall, and Pegues, are included in the lists of "Honorary Managers" and "Managers." (Courtesy of Lanier Robison.)

13

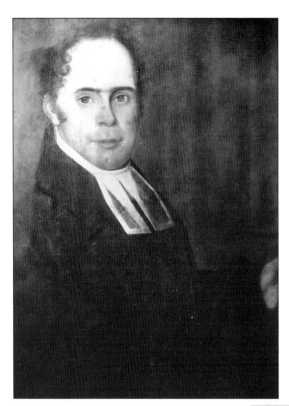

A YOUTHFUL PORTRAIT OF THE REVEREND DANIEL BAKER, MINISTER OF HOLLY SPRINGS PRESBYTERIAN CHURCH FROM 1840 TO 1848. The well-known Reverend Daniel Baker was born in Georgia in 1791 and traveled extensively during his career. Both of Baker's sons entered the ministry as well. (Courtesy of Milton Winter.)

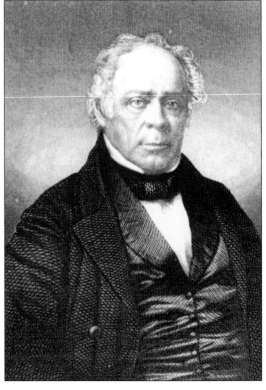

THE REVEREND DANIEL BAKER IN LATER LIFE. During his ministry in Holly Springs, the Reverend Baker and his Presbyterian elders found it advantageous to excommunicate Harvey Washington Walter, one of the city's most prominent citizens, in part due to his love of dancing. Walter died in 1878 after opening his home, Walter Place, as a yellow fever hospital. H. W. Walter continued to contribute to the Presbyterian church despite his excommunication; church elders published a memorial to Walter after his death. (Courtesy of Milton Winter.)

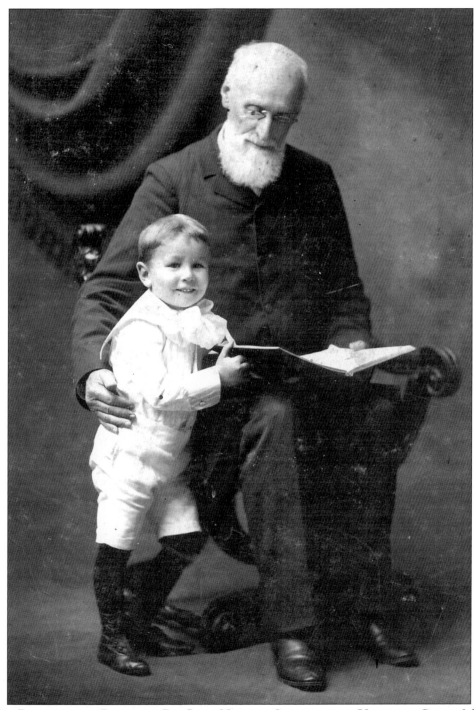

THE PRESBYTERIAN REVEREND DR. JOHN NEWTON CRAIG AND AN UNKNOWN CHILD. John N. Craig was pastor of Holly Springs's Presbyterian church during the yellow fever plague of 1878. The hardships and sorrow he endured can only be imagined. (Courtesy of Milton Winter.)

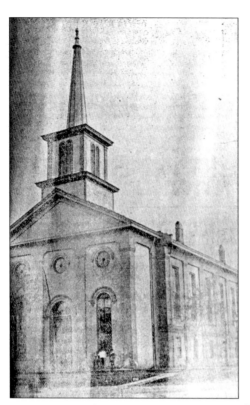

ORIGINAL METHODIST CHURCH, C. 1896.
This church was built in 1849. The front of the
building was modified between 1869 and 1870;
originally open, the entryway was enclosed
during the remodeling and remains enclosed
today. The sanctuary's interior is beautifully
lit on sunny days by enormous stained-glass
windows. (Courtesy of Milton Winter.)

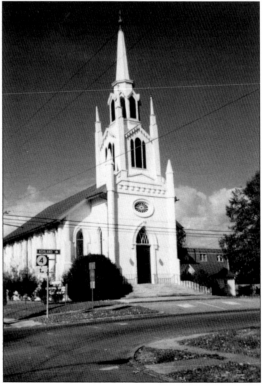

CHRIST EPISCOPAL CHURCH. This 1850s
structure has withstood 19th-century
warfare and a 1920s fire, although its
entire steeple was replaced after the blaze.
An ingenious design, the steeple is far
more fireproof; it is made of tin. (Courtesy
of Milton Winter.)

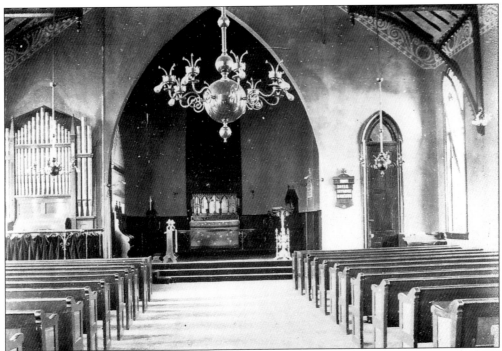

THE SANCTUARY OF CHRIST EPISCOPAL CHURCH, 1950S. Even to this day, this grand old church retains much of its mid-19th-century appearance and charm. The Reverend Bruce McMillan is pastor in 2006. (Courtesy of Anne Reed.)

THE INTERIOR OF THE RED BANKS, MISSISSIPPI, PRESBYTERIAN CHURCH. Only a few miles west of Holly Springs, Red Banks's Presbyterian church, built in 1888, has changed very little over the decades. The Reverend Milton Winter, present minister of Holly Springs's Presbyterian church, has overseen the building's restoration. (Courtesy of Milton Winter.)

THE HUDSONVILLE PRESBYTERIAN CEMETERY. Only 10 miles from Holly Springs, this cemetery, next to the Hudsonville Presbyterian Church, had its first burial in the 1830s. This photograph was taken by the Reverend Milton Winter in the late 1950s. (Courtesy of Milton Winter.)

THE OLD SPRING CREEK PRESBYTERIAN CHURCH NEAR WATERFORD, MISSISSIPPI, JUST OUTSIDE OF HOLLY SPRINGS. This 1958 photograph shows the early 20th-century church in decay; it was torn down around 1960. (Courtesy of Milton Winter.)

THE ORIGINAL EPISCOPALIAN CHURCH IN
HOLLY SPRINGS, BUILT IN 1841. After the
Christ Episcopalian Church was completed,
this building became a Catholic church and was
moved to its present location on College Avenue
in the 1850s. Today it serves as Holly Springs's
Yellow Fever Martyrs' Church and Museum,
which is open for tours by appointment. In
this late-19th century or early-20th century
photograph, the unidentified individuals in the
foreground appear blurry; they moved before the
photographic exposure was complete. (Courtesy
of Milton Winter.)

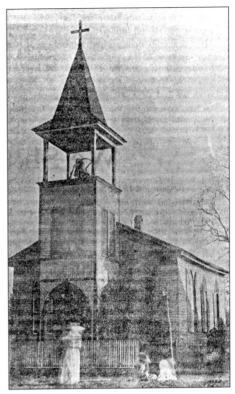

THE FIRST PRESBYTERIAN
CHURCH OF HOLLY SPRINGS.
This beautiful structure was
used as a stable by occupying
Union troops during the
War Between the States.
Its original pews are in the
sanctuary, and its façade
is marked by shrapnel and
minie balls fired during
Holly Springs's numerous
Civil War skirmishes. The
photograph shown here
is from the 20th century.
(Courtesy of Milton Winter.)

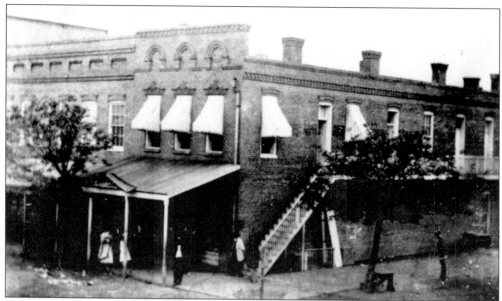

ISSAC C. LEVY'S CLOTHIERS, 1880S. One of a number of Jewish merchants to come to Holly Springs in the 19th century, I. C. Levy left his name upon the tiled threshold of what today is Linwood's Clothing Store, owned by the descendants of Ernest G. Miller, who appears on this book's cover. (Courtesy of Milton Winter.)

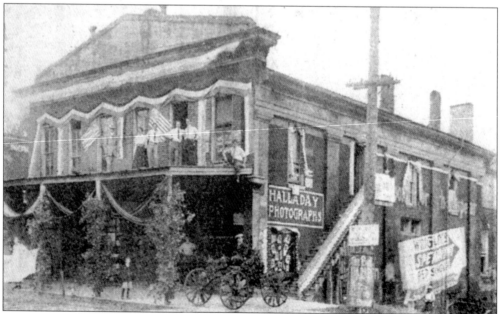

ERNEST G. MILLER'S GENERAL MERCHANDISE, EARLY 20TH CENTURY. On the southwest corner of the square, this building, decked out for what may be a Fourth of July celebration, boasted a rooming house upstairs. Downstairs, it housed Miller's General Merchandise, which offered customers an astounding assortment of items. One could purchase "anything from a dress to an appliance to an automobile." The Miller family still owns this building, which stocks a fine selection of shoes and handbags to this day. (Courtesy of Milton Winter and the Miller Family.)

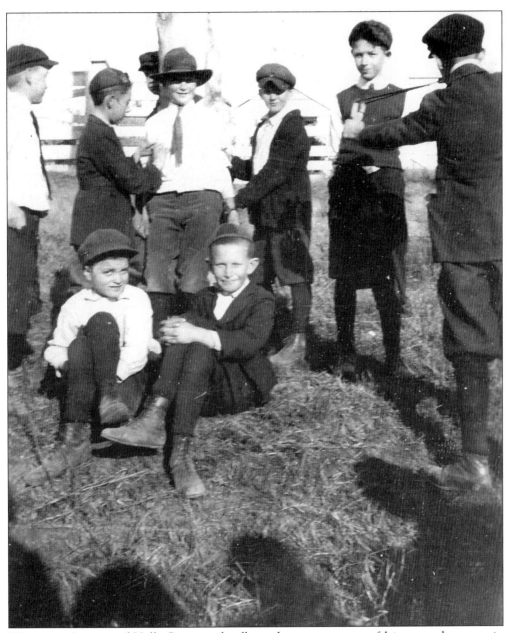

MISCHIEF. A group of Holly Springs schoolboys shares a moment of leisure as they pose in mockery of a firing squad. Note the boy on the far right, aiming his slingshot at the young man in the photograph's center, who stands "under guard" against a pole while he awaits "execution." (Courtesy of Milton Winter.)

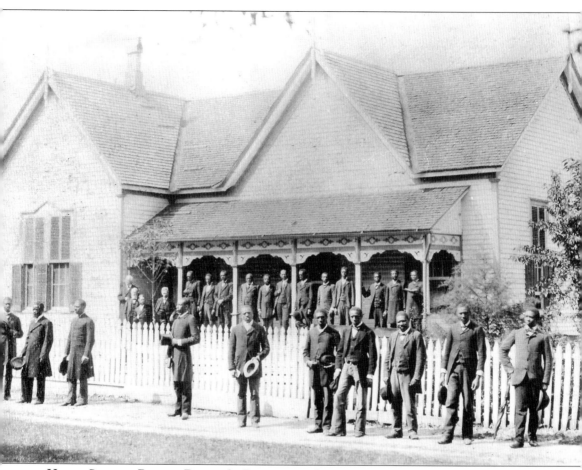

HOLLY SPRINGS PASTOR DAVID C. RANKIN AT STILLMAN COLLEGE IN ALABAMA, 1885.
Besides his Holly Springs ministerial duties, Rankin was a professor at Stillman College. He is seen here on the left side of the porch, third from the end. (Courtesy of Milton Winter.)

Two

HISTORIC HOMES AND GRAND MANSIONS

Many antebellum homes still stand in Holly Springs due to the South's lack of revenue following the Civil War; houses and other structures that would have been torn down and replaced by newer, more modern buildings continued to be used because their owners lacked the means to rebuild them. One of the supreme ironies of Reconstruction and occupation is Holly Springs's enduring wealth in terms of what, during the post-war decades, were considered to be old-fashioned and outdated structures. Today, with a few exceptions, these homes are once again treasured.

Over the years, the Holly Springs Garden Club has restored a few houses that were in danger of falling into ruin. One such home is Gray Gables, which the club purchased in the early 1950s; Gray Gables's decline and renovation are featured in the following pages. Lois Swaney, curator of the Marshall County Historical Museum, purchased Gray Gables as a private residence in 1962, and the home has belonged to private owners ever since. Another Garden Club project is Montrose, an impressive 1858 brick structure, which currently serves as the club's home. In the 1930s, the club restored the Malone House, which stood on the corner of Alderson Street and College Avenue. Built in the 1830s with walls two feet thick and a formal garden, the Malone House was in good shape in 1987 when it was purchased by a developer who destroyed the house, paved its site, and built a store in its place before selling the business and leaving Holly Springs.

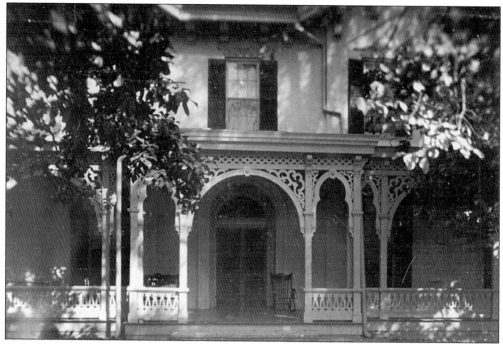

ITALIANATE DETAIL ADDED TO GRAY GABLES BY JAMES J. HOUSE IN THE 1870s. Built in the 1830s, Gray Gables nearly tripled in size under the ownership of James "J. J." House, who hired a Memphis architect to remodel the home. Spiral staircases, exterior details, and extravagant window glass were added. This 1950s photograph shows the home under restoration. (Courtesy of Joey Miller.)

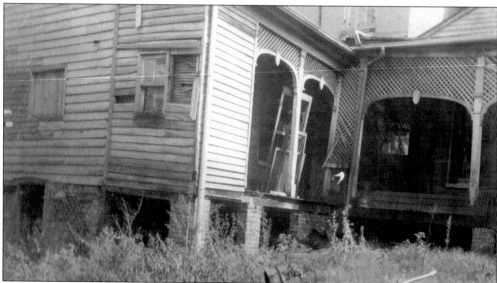

A REAR VIEW OF GRAY GABLES IN THE EARLY 1950s. Overgrown and decaying, the home no longer reflects the fortune J. J. House made during the Civil War. He allegedly accepted only Yankee greenbacks for payment; his wealth allowed him to make of Gray Gables the last great mansion built in Holly Springs before the hard times of Reconstruction. Even plumbing was installed in Gray Gables. (Courtesy of Joey Miller.)

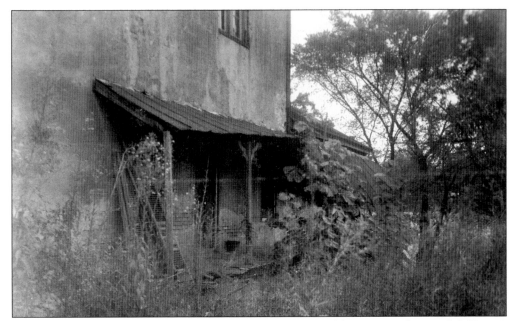

A Picturesque but Heartbreaking Ruin. Here Gray Gables seems to forecast J. J. House's financial fate—he lost his fortune in Holly Springs and left, bankrupt, in 1875. Luck was still with House, however; he went to Tennessee and then to Alabama, where he amassed another fortune while escaping the yellow fever epidemic that plagued Holly Springs in 1878. (Courtesy of Joey Miller.)

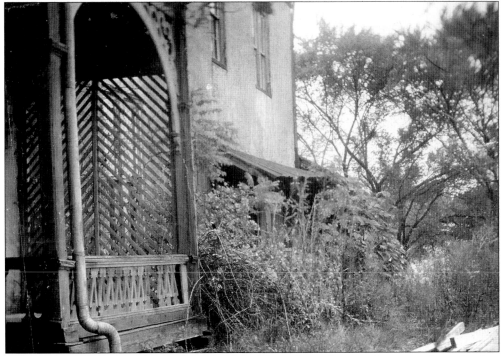

Gray Gables' Ornate Details in Neglect. This side porch reminds a view of grander days as the home languishes. (Courtesy of Joey Miller.)

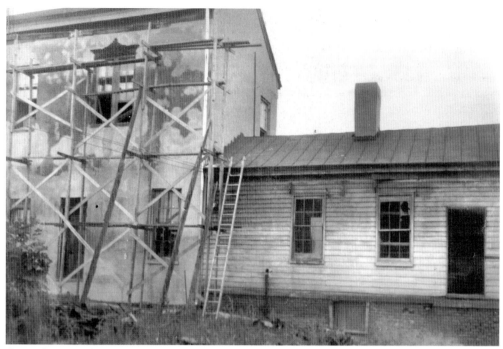

GRAY GABLES: THE HOLLY SPRINGS GARDEN CLUB'S RESTORATION UNDERWAY. Scaffolding and ladders promise better days ahead. Some of J. J. House's ornate exterior detailing is visible behind the scaffolding at left. (Courtesy of Joey Miller.)

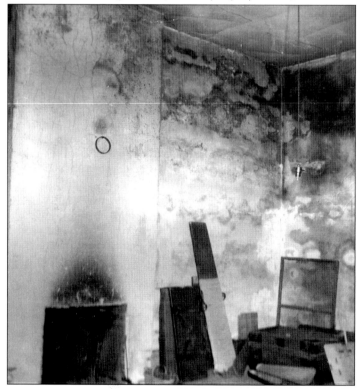

AN INTERIOR VIEW OF GRAY GABLES STILL IN NEAR RUIN. No mantle graces the gaping fireplace in this chipping plaster wall. All sense of grandeur has been stripped from this "old gray lady." The devastating effects of North Mississippi's humid climate can be seen in this startling photograph. (Courtesy of Joey Miller.)

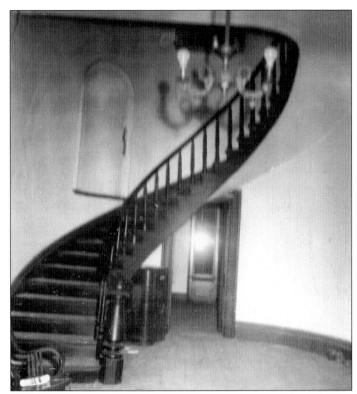

GRAY GABLES' SPIRAL STAIRCASE UNADORNED. Clean but not decorated, J. J. House's elegant stairway still needs tender loving care. Restoration of the home is underway in 2006. (Courtesy of Joey Miller.)

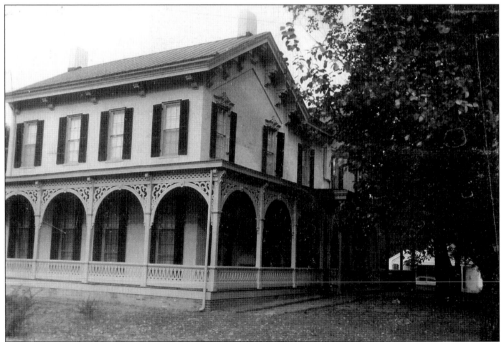

ITALIANATE DETAIL IN FINE FORM AFTER THE 1950S RESTORATION. A view of Gray Gables from the southwest gives a complete picture of this expansive home, much as J. J. House intended, excluding the automobile in the bottom-right corner. (Courtesy of Joey Miller.)

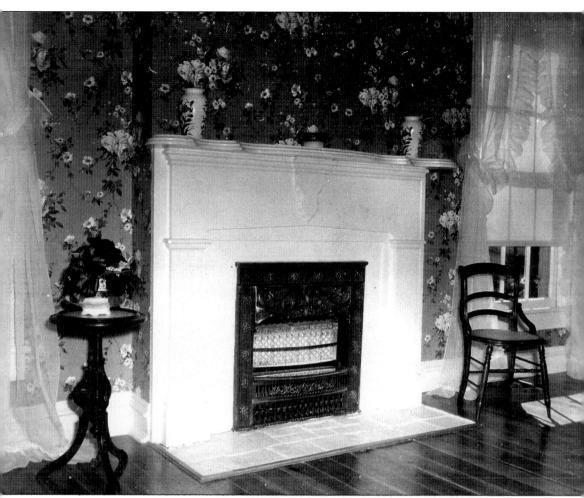

RESTORATION COMPLETE. This interior view of Gray Gables shows a room made lovely once again, despite the "modern" gas heater fitted squarely into the fireplace. A patch of sunlight through the bottom three panes of a six-over-six window adds its smile to the picture. (Courtesy of Joey Miller.)

BEFORE. The unrestored vestibule of Gray Gables shows cracked and broken plaster, damaged floorboards and woodwork, and evidence of a leak that has made its way from the roof to the first floor. (Courtesy of Joey Miller.)

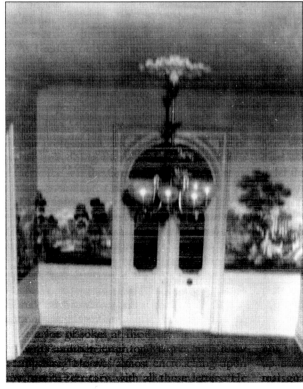

AFTER. The vestibule of Gray Gables is restored. Gone are the signs of neglect, and in their place are refinished floors, painted woodwork, a new chandelier, and a 19th-century-style mural. (Courtesy of Joey Miller.)

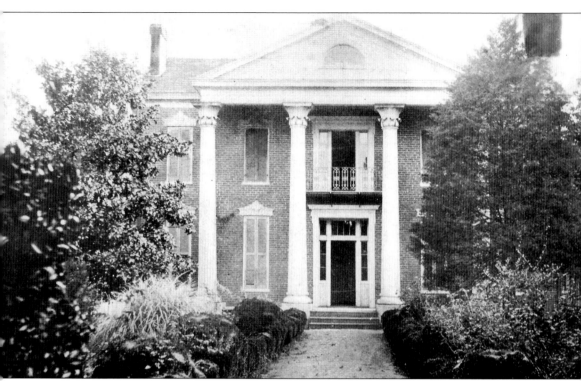

THE POINTER HOME. In the late 1860s, this house was bought by Bethlehem Academy, from which an ancestress of Lanier Robison graduated. As a handwritten note from the collection of Robison tells us, Bethlehem was a "school for young ladies" that purchased the home after it "outgrew the Carrington Mason Home [later the Dr. Samuel Hamilton home] at the end of Memphis Street, in which they opened in 1868." Bethlehem Academy was run by the Catholic Sisters of Charity, who, along with Fr. Anacletus Oberti, nursed yellow fever sufferers during the 1878 epidemic. Father Oberti and five nuns also died of fever between September 22 and October 11, 1878. The Pointer home was razed; a sandpaper factory stood on its site in the 1960s. (Courtesy of Lanier Robison.)

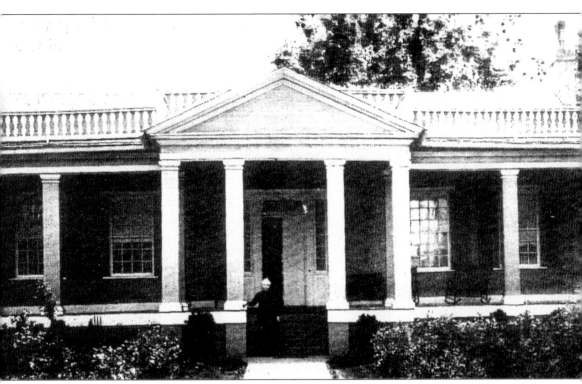

AN EARLY-20TH-CENTURY PHOTOGRAPH OF CRUMP PLACE. Built by Sam McCorkle in 1837, this one-story structure housed officers during the Civil War and was the boyhood home of Edward Hull Crump Jr., later famous as "Boss Crump" of Memphis, Tennessee. Crump's father died of yellow fever in 1878 and is buried in Holly Springs. Mollie Nelms Crump, Boss Crump's mother, can be seen here on the porch; she always wore black after her husband died of yellow fever during the great epidemic of 1878. (Courtesy of David Person, Edward Rather, and Marie Rather McClatchy.)

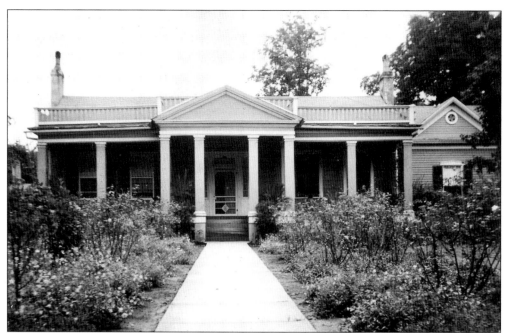

A Later Photograph of Crump Place. Here Crump Place has received a modern screen door and screened windows—innovations that might have saved lives during the 1878 yellow fever epidemic, had the world known that the disease is spread by the *aedes aegypti* mosquito. (Courtesy of David Person, Edward Rather, and Marie Rather McClatchy.)

Crump Place's East Back Gallery under Renovation around 2000. Even in this wing, added long after the original 1837 house was completed, old shutters and mantels required careful restoration before they could be reattached to plaster walls and exterior clapboard. (Courtesy of David Person.)

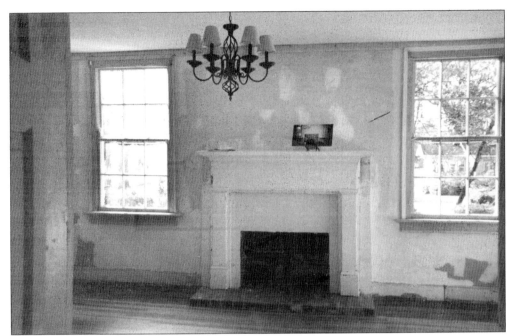

CRUMP PLACE: INTERIOR OF MAIN HOUSE UNDER RENOVATION. In this photograph, this part of Crump Place is on its way to becoming a modern kitchen. Adjoining this contemporary kitchen is a center room still bearing its original plaster. (Courtesy of David Person.)

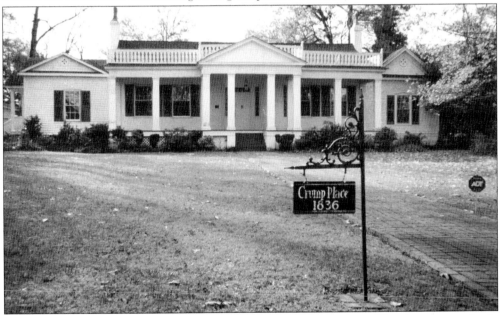

CRUMP PLACE SAVED: 21ST-CENTURY RESTORATION COMPLETED. This home, completely restored by David Person, hosted a luncheon in 2004 to which members of the Presbyterian church walked to the accompaniment of a bagpipe. Crump Place was also featured in the 2005 Holly Springs Spring Pilgrimage. Even Crump Place's exterior walls have been returned to their original color, a muted yellow, which Mollie Nelms Crump described as "Colonial beige." (Courtesy of David Person.)

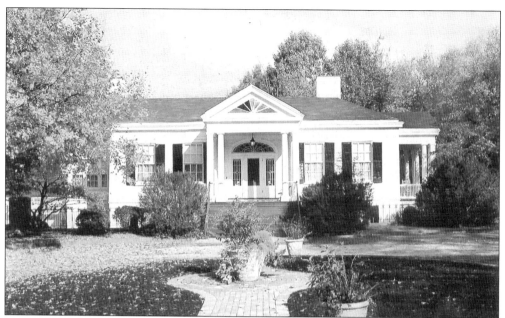

FEATHERSTON PLACE FROM THE SOUTHEAST, LATE 20TH CENTURY. Alexander McEwen built this home in 1834. His daughter, Elizabeth, married Gen. Winfield Scott Featherston. Their family was stricken here with yellow fever in 1878. In the 20th century, Oscar Johnson purchased the home and hired architect Theodore Link to remodel and enlarge it. This house, along with Polk Place, was purchased by Mike and Jorja Lynn in 2003. (Courtesy of Frances Buchanan.)

THE FRONT WALKWAY OF WALTER PLACE, 1940s. An unknown visitor poses in front of Holly Springs's grandest antebellum home. (Courtesy of Claiborne Rowan Thompson.)

WALTER PLACE IN THE 1940S. Construction of this magnificent home began in 1857 and took two years to complete. U.S. general Grant used the home as his personal headquarters; later its builder, H. W. Walter, along with his three sons, died of yellow fever here in 1878. Behind the unidentified children in this photograph, note the east turret of the house, which is visible in the background on the right. (Courtesy of Claiborne Rowan Thompson.)

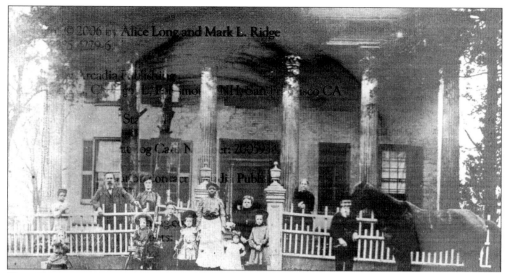

THE HOME OF DR. SAMUEL D. HAMILTON, C. 1902. In 1892, Dr. Samuel Hamilton bought this home, originally built for the Carrington Mason family in 1840. A 1927 fire resulted in the home's present-day style. Pictured from left to right are (outside the fence) Marjorie Hamilton Jennings, Margaret Totten Loftin, George Hamilton, Lillie Mullins Walker, "our nurse" Virginia, Mary Brooks Mullins, Frances Hamilton Rather, Mary Totten Tucker, Sam Hamilton Jr., and Cadmus, "one of Dr. Hamilton's fine Kentucky horses;" (inside the fence) Edie Martin (Marjorie Hamilton Jennings's nurse), Dr. Hamilton, Lillie Hamilton Arrington, and Mrs. Jolly, the housekeeper. The quotations are from handwritten notes accompanying this photograph from the family collection of Lanier Robison. (Courtesy of Lanier Robison and Chelius Carter.)

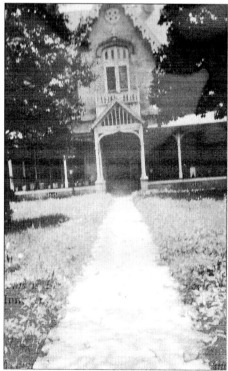

AIRLIEWOOD (FORMERLY COXE PLACE) IN THE 1920s. This house was begun in 1856 by Amelia and William Henry Coxe, although the home was not finished by the time of Amelia's death in 1857. During the Civil War, the house was Grant's military headquarters. By the 1920s, the home was owned by the prominent Thompson family of Holly Springs. (Courtesy of Claiborne Rowan Thompson.)

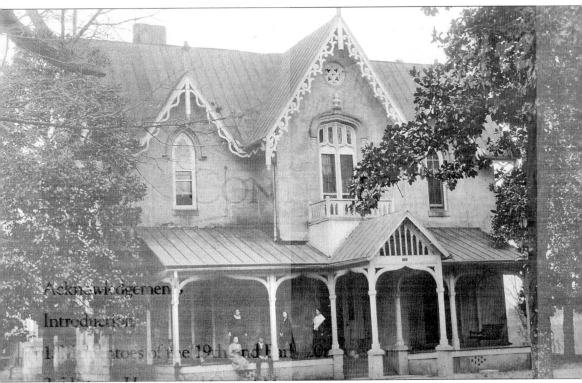

THE THOMPSON FAMILY, 1920s. Period costumes add a festive air at Airliewood, which had seen the ravages of Gen. Ulysses S. Grant's troops while the home was used as a military headquarters during the Union occupation of Holly Springs. Stories of Yankees vandalizing the large gate guarding the lane that led from Salem Street to Airliewood's front door are still told today. (Courtesy of Claiborne Rowan Thompson.)

A 1960s View of Lunati Farm with Outbuildings. An Assembly of God minister who also delivered "prophetic" sermons in Holly Springs, the Reverend P. J. Lunati had this stone and wood structure built during the Great Depression as a hunting lodge near Chewalla Lake, just outside Holly Springs. The area soon became known as Lunati Farm; a church was built nearby, along with several log cabins and a stone dairy barn that had curtains painted on its interior walls. Thanks to the Reverend Lunati's efforts, many residents of Holly Springs were able to find employment on this farm through the Depression, and the Bank of Holly Springs, unlike most of its competitors, remained open during this trying time. (Courtesy of Katherine and Joyce Delashmit.)

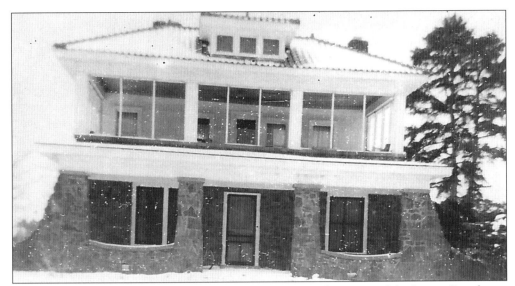

THE HOUSE OF STONE AND STURDY TIMBER, 1960S. A close view of the Lunati Farmhouse shows the determination of the man who built it. By the 1960s, the building pictured here had changed from hunting lodge to farmhouse in which the Reverend Marshall Delashmit, also an Assembly of God minister, lived with his wife, Katherine, and their children. (Courtesy of Katherine and Joyce Delashmit.)

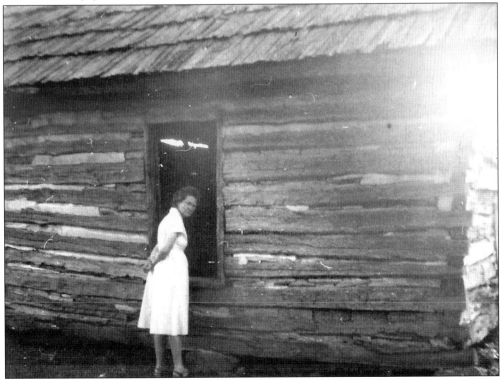

KATHERINE DELASHMIT EXPLORING A RAMSHACKLE LOG OUTBUILDING AT LUNATI FARM, 1960S. Several log cabins, one of which was an elegant two-story structure, once stood near Chewalla Lake next to Lunati Farms. (Courtesy of Katherine and Joyce Delashmit.)

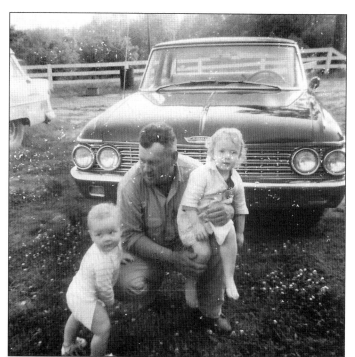

THE REVEREND MARSHALL DELASHMIT WITH TWO GRANDCHILDREN, LUNATI FARM, 1960S. Providing work for many Marshall County, Mississippi, residents, as did the Reverend Lunati before him, Marshall Delashmit managed Lunati Farm 1960 until 1973. Marshall Delashmit died in September 2004, leaving a legacy of good works and good will. (Courtesy of Katherine and Joyce Delashmit.)

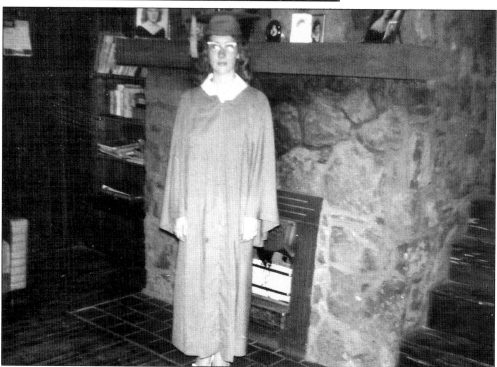

A STONE HEARTH INSIDE THE LUNATI FARMHOUSE, 1960S. Joan Delashmit stands in Holly Spring High School's graduation regalia before one of several large stone fireplaces that still grace the Lunati house. This particular fireplace was "updated" with a gas insert. (Courtesy of Katherine and Joyce Delashmit.)

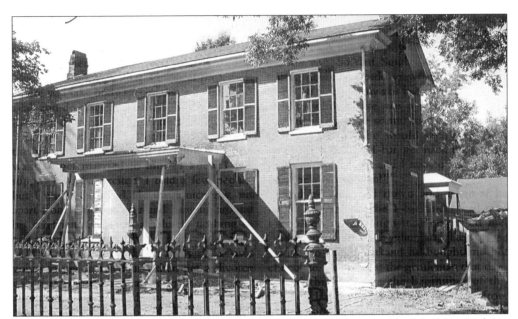

Burton Place in the Offing, 2005. This home on Memphis Street was built by Mary Malvina Shields Burtion in 1848. Known for decades as "Fleur de Lys" and labeled such on a metal sign denoting this as an antebellum house, Burton Place is undergoing a thorough remodeling by new owner David Person, who is working under the direction of preservation architect Chelius Carter. The home will be renamed Burton Place for this 1848 builder. (Courtesy of David Person.)

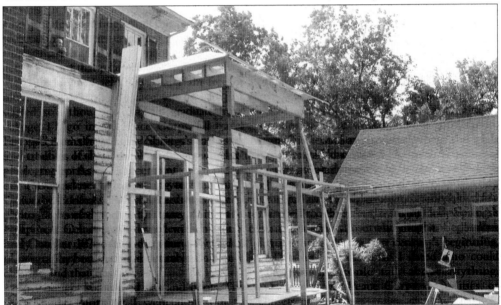

Burton Place (Fleur de Lis), North Side and Detached Kitchen/Laundry, 2005. The detached structure on the right side of this photograph is a three-roomed building that contains a kitchen, a laundry, and living quarters. The black-and-white shingle hanging at a tilt to the right of the kitchen door is a marker used to denote houses open for viewing during Holly Springs's Annual Spring Pilgrimage. The revamped Burton Place is scheduled to be open for the 2006 Pilgrimage. (Courtesy of David Person.)

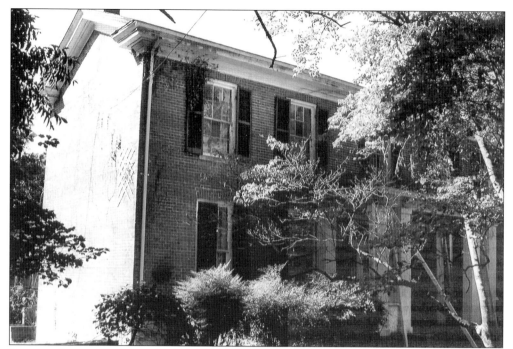

BURTON PLACE (FLEUR DE LIS), SOUTH SIDE, 2005. This home's front yard is still framed by the wrought iron fence that stood around Holly Springs's Marshall County Courthouse from 1872 until 1927. (Courtesy of David Person.)

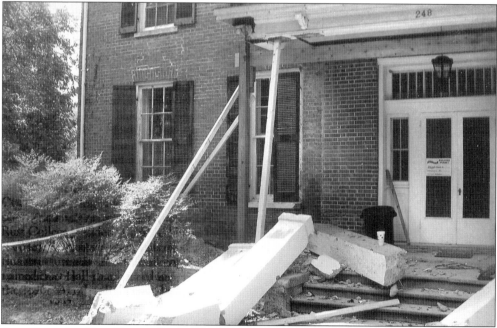

AND THEY ALL FALL DOWN. Soon-to-be Burton Place stands propped up by makeshift supports while damaged Doric columns are being replaced. The fine brickwork and still-working shutters are clearly visible in this photograph. This careful restoration promises to bring new life to one of Holly Springs's most beautiful antebellum homes. (Courtesy of David Person.)

Three

THE 20TH CENTURY PROGRESSES

Like other cities in America, Holly Springs saw an increase in population and development during the 20th century. As evidenced by the following photographs, the city embraced the new technologies of the telephone, the automobile, and the radio eagerly. Reconstruction's financial paralysis had been broken, and Holly Springs progressed in an era that boasted of humankind's mastery over the world. World wars, Depression, and the boom of the 1950s bent then boosted Holly Springs, whose residents endeavored to keep light hearts through unsettled years and a rollicking *joie de vivre* through flush times.

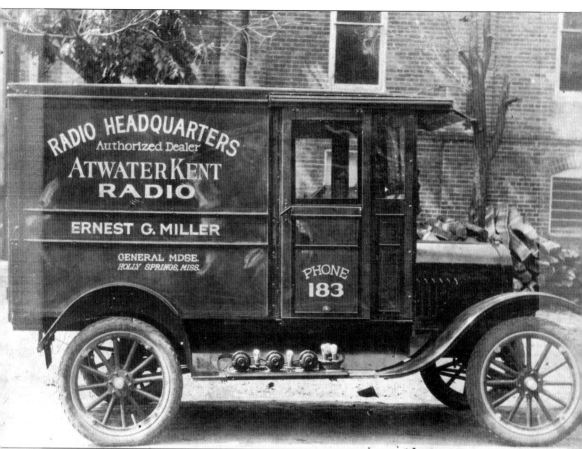

ERNEST G. MILLER'S "RADIO" MODEL T. Ernest Miller's General Merchandise sold radios—true novelties when they were the latest in technology. Miller often left radios with prospective buyers for a week, after which customers were unlikely to part with them. Miller's truck even carried a radio on its right running board. Here the Model T flanks the north side of Miller's store, heading west on Van Dorn Avenue. (Courtesy of Graham Miller and Milton Winter.)

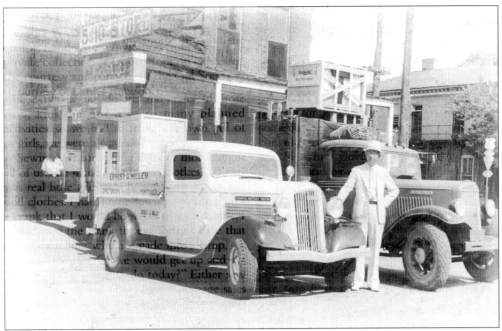

ERNEST G. MILLER CUTTING A FINE FIGURE. If you purchased items small enough to carry, you would not have needed Ernest Miller's General Motors delivery truck. Iceboxes or washing machines would have been brought to your door by one of Holly Springs's finest and most diverse enterprises. From the late 1840s until 1860, the Miller building was the home of the Presbyterian church. (Courtesy of Milton Winter and the Miller Family.)

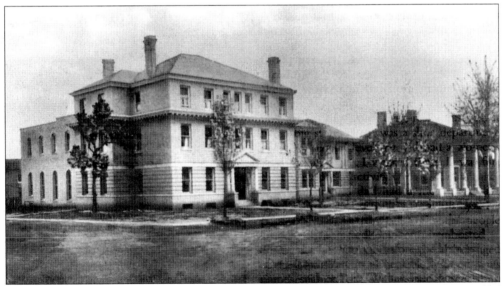

MISSISSIPPI SYNODICAL COLLEGE, EARLY 20TH CENTURY. The structures to the left (east) of this building were subsequently razed. Today the former Mississippi Synodical College is the permanent home of the Marshall County Historical Museum, under the leadership of curator Lois Swaney. (Courtesy of Lanier Robison.)

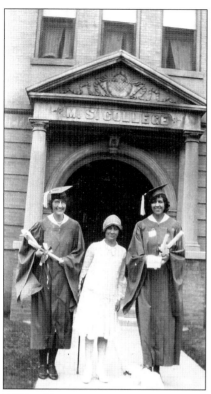

MISSISSIPPI SYNODICAL COLLEGE STUDENTS, 1920S. Founded as Fenelon Hall at the close of the Civil War, this school for women became Maury Institute by the 1880s. The Presbyterian Church bought the school in 1891, renaming it North Mississippi Presbyterian College. By 1902, the name had changed to Mississippi Synodical College. Pictured here from left to right are Eunice Graves of Memphis (Class of 1927), Monique Scott of Itta Bena (Class of 1926), and an unidentified woman, who appears in the following photograph, in the back row fourth from the left. (Courtesy of Milton Winter.)

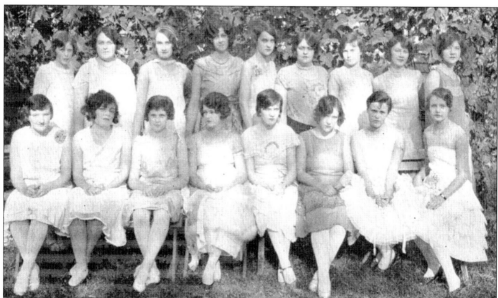

MISSISSIPPI SYNODICAL COLLEGE'S GRADUATING CLASS OF 1927. Among the young ladies taking their degrees are Laura Power of Alford, Mississippi; Velma Agee of Baldwyn, Mississippi; Monique Scott of Itta Bena, Mississippi; and women from as far away as Florida, North Carolina, and even Idaho. Although Eunice Graves is seated to the far left in the front row, no other person can be identified. These young women's sense of style is obvious as are the fashions and trendy haircuts of graduating college seniors today. (Courtesy of Milton Winter.)

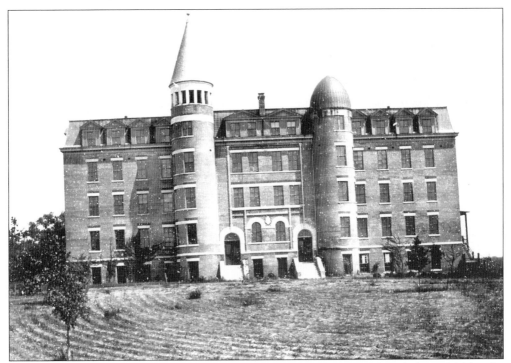

RUST HALL AT RUST COLLEGE IN THE 1920S. Rust College was founded in 1866 by the Freedmen's Aid Society of the Northern Methodist Episcopal Church and offered higher education to African Americans. Wise land use is evident in this photograph; during hard times, Rust used its front lawn as a field in which crops to feed students were grown. The structure pictured here was destroyed by fire in 1940. (Courtesy of Anita Moore and the Rust College Archives.)

NATALIE DOXEY AND HER TRAVELING SINGERS, RUST COLLEGE, 1940S. Natalie Doxey founded the famous Rust College A Cappella Choir, which is still singing today under the direction of Prof. Zebedee Jones. (Courtesy of Anita Moore and the Rust College Archives.)

THE CONQUEST PERFORMED ON THE RUST COLLEGE LAWN, 1920S. Rust College's first dramatic organization was founded in 1925. Theater is still active at Rust College under the command of Prof. John Arthury House, who directs and writes many of the plays performed on campus. (Courtesy of Anita Moore and the Rust College Archives.)

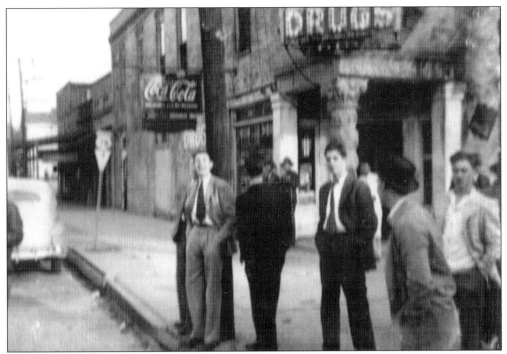

HANGING AROUND, 1940S. Tyson Drug Store is still a popular corner on the Holly Springs square, and a soda fountain along with an old-fashioned hand-scooped ice cream counter, remain open inside. (Courtesy of Bob Lomenick.)

A SUMMER STROLL ALONG THE SQUARE, 1930S. Not only merchandize in a window display can be seen here. Note the reflections in the storefront's glass. (Courtesy of Claiborne Rowan Thompson.)

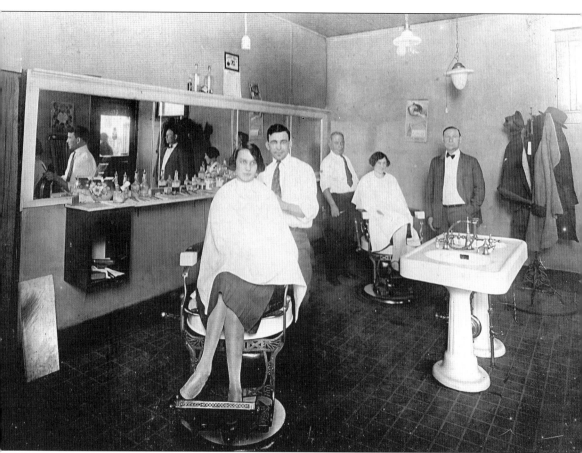

DOWNTOWN HOLLY SPRINGS BARBERSHOP, 1920s. Owned at the time by the Hedderick Family, this barbershop once occupied the building that is presently Robinson's Drug Store on the north side of the square. Featured here are Otto Hedderick, the barber on the left; Bruce Bowers, wearing a suit; and Otto's partner, the second barber. The other clientele are unidentified. (Courtesy of Anne Reed.)

THE REVEREND DR. HOMER MCLAIN, PRESBYTERY HOME MISSIONS WORKER, 1926–1956. Dr. McLain preached in Hudsonville, Red Banks, Lamar, and Byhalia, Mississippi, during his time in the Holly Springs area. Born in Acworth, Georgia, in 1878, he served his church in Holly Springs until his death. (Courtesy of Milton Winter.)

THE REVEREND EDWIN G. TOMKINSON, HIS WIFE, IRENE, AND HIS DAUGHTER, ROBERTA. The Reverend Tomkinson served as Presbyterian minister in Holly Springs from 1934 to 1937. Born in England in 1887, Tomkinson lived in Canada, Ohio, and Florida before coming to Holly Springs. He left Mississippi in 1937 and moved to Helena Arkansas. (Courtesy of Milton Winter.)

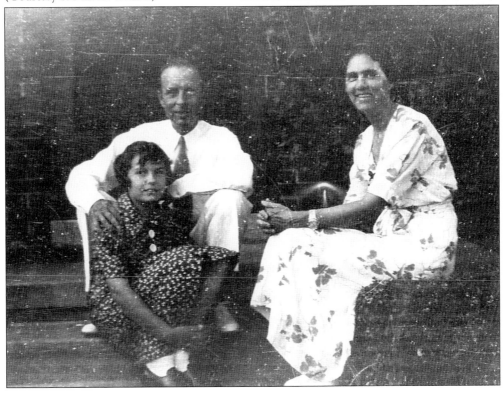

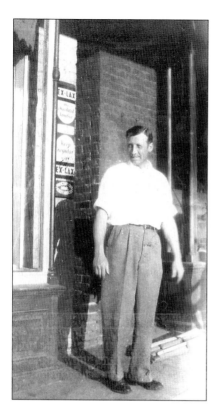

PHARMACIST BEN THOMPSON, NEW OWNER OF THE S. R. CRAWFORD DRUG STORE, 1930S. A member of Holly Springs's prestigious Thompson family, Ben S. Thompson rose from the position of "prescription clerk" in 1930 to become the owner of his own business on the east side of the town square. His career was not a long one. Ben Thompson died in 1950, leaving his wife, Claiborne Rowan Thompson, to raise their two surviving children. (Courtesy of Claiborne Rowan Thompson.)

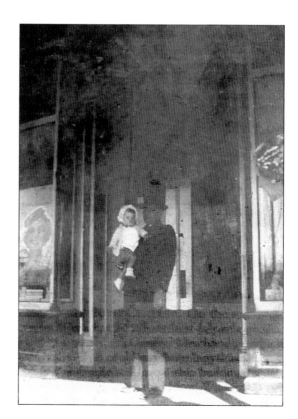

DR. EDWARD THORNE AND DAUGHTER HELEN, 1930S. Dad is holding his daughter in front of Ben Thompson's drug store on Market Street. (Courtesy of Claiborne Rowan Thompson.)

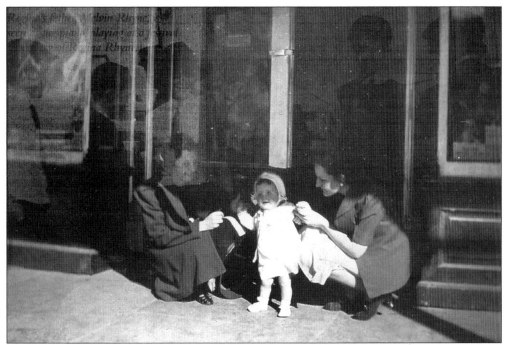

THOMPSON'S DRUG STORE, 1930S. Claiborne (Mrs. Ben) Thompson (right) and an unidentified friend play with toddler Helen Thorne. The afternoon sun highlights little Helen's dress as she anchors herself between her adult companions. (Courtesy of Claiborne Rowan Thompson.)

"LITTLE BEN" THOMPSON AND HIS FIRST DOG, BOOTS, 1930S. Boy and pup share an afternoon's sunshine in front of Dad's drug store. This child was the first son of Ben and Claiborne Rowan Thompson. Sadly the boy died before his third birthday. His grave marker in Holly Springs's Hill Crest Cemetery reads, "Little Ben." (Courtesy of Claiborne Rowan Thompson.)

MAE ALICE BOOKER, 1935. Booker stands in front of her 1834 home Alicia on Chulahoma. Never married, Mae Mae Booker lived in this house most of her life. Alicia changed hands in 2005. (Courtesy of Claiborne Rowan Thompson.)

FELICIA BOOKER, SISTER OF MAE ALICE, AND YOUNG JIMMY FRENCH, 1936. Sunshine brightens a winter day. In the right background stands the Marshall County Courthouse, built in the 1870s and used as a hospital during the yellow fever epidemic of 1878. (Courtesy of Claiborne Rowan Thompson.)

MRS. RICHARD "POKIE" FRENCH AND HER SON, JIMMY, 1936. This photograph offers a better view of the street facing the courthouse and clearly refutes the notion that women in Mississippi find the weather too warm to wear fur. (Courtesy of Claiborne Rowan Thompson.)

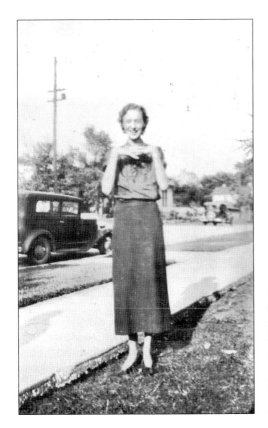

FELICIA BOOKER "POSING," 1934. A summer ensemble, a stylish coiffure, two period *autovoitures*, and what was then a new sidewalk complete this charming picture of Holly Springs's good-natured enjoyment of everyday life. The photograph's title comes from Claiborne Rowan Thompson's handwriting on its reverse side. (Courtesy of Claiborne Rowan Thompson.)

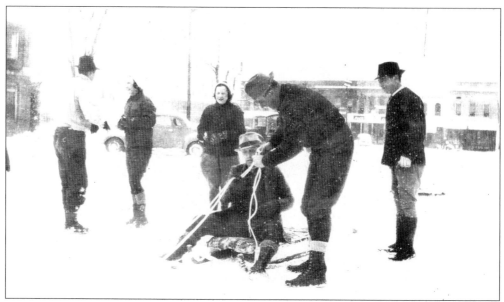

A Holly Springs Snow on Market Street, 1940. From left to right, C. C. Stephenson, Margaret Rather, Ruth Thorne, Gus Smith, Ben Thompson, and Jack Slayden have an adventure with a sled in an unusually thick Mississippi snow. (Courtesy of Claiborne Rowan Thompson.)

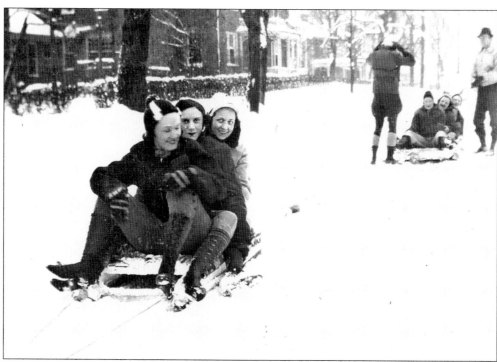

A Two-Sled Snow Day, 1940. From left to right on the front sled are Jean Seale, Mildred Jones, and Pokie French. On the back sled from left to right are Maxine Stephenson, Claiborne Thompson, and Felicia Booker. Standing are Margaret Rather and C. C. Stephenson in front of the former Mississippi Synodical College. (Courtesy of Claiborne Rowan Thompson.)

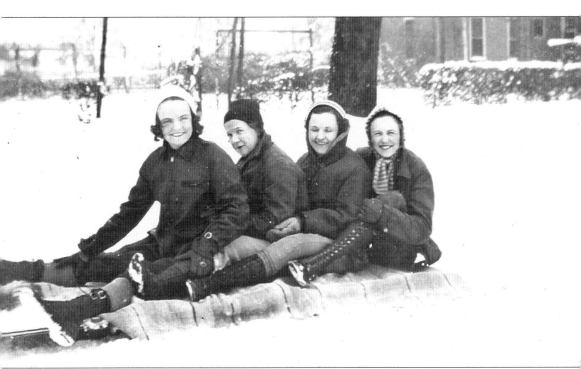

MORE FUN IN THE SNOW, 1940. From left to right, Margaret Rather, Maxine Stephenson, Claiborne Thompson, and Felicia Booker take a turn on the sled. The building in the background is the former Mississippi Synodical College, now the permanent home of the Marshall County Museum. (Courtesy of Claiborne Rowan Thompson.)

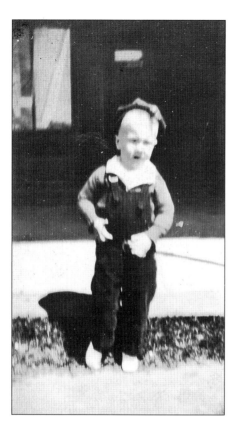

LITTLE BEN THOMPSON, 1940S. From stroller to overalls in just a year's time, Little Ben Thompson is ready for springtime outside his father's drugstore on the square. (Courtesy of Claiborne Rowan Thompson.)

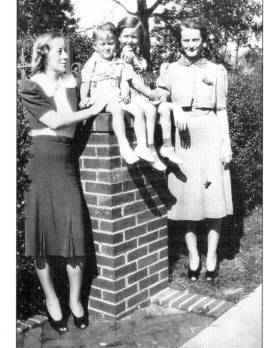

UNIDENTIFIED SUMMERTIME VISITORS AT WALTER PLACE ON CHULAHOMA, 1940S. Still a major attraction in Holly Springs today, the front walkway of Walter Place gets the attention of tourists and locals alike. (Courtesy of Claiborne Rowan Thompson.)

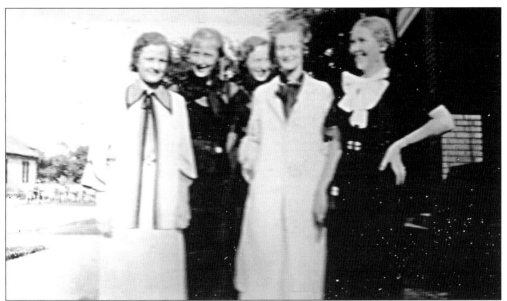

A 1940s View of Gholson Avenue. This group of Holly Springs ladies is standing in front of a structure that began its existence as an antebellum home. In the 20th century, it was converted into an apartment building, although its wide foyer recalls pre-Civil War days. From left to right are Claiborne Rowan Thompson, Eleanor Coopwood, Felicia Booker, Lou ?, and Miriam Sutton.

The Bowers Brothers, Summer 1930. These young men are cooling off just outside the city limits of Holly Springs on the main route, Highway 7. (Courtesy of Anne Reed.)

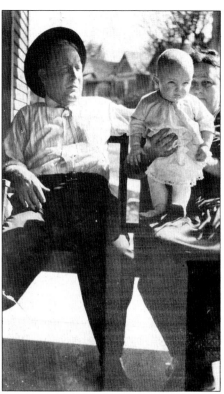

BABY ANNE HEDDERICK, C. 1923. "Uncle Bruce" and "Aunt Mamie" Bowers accompany Anne in this photograph taken on the front porch of 911 Memphis Street in Holly Springs. House numbers have since been reassigned. (Courtesy of Anne Reed.)

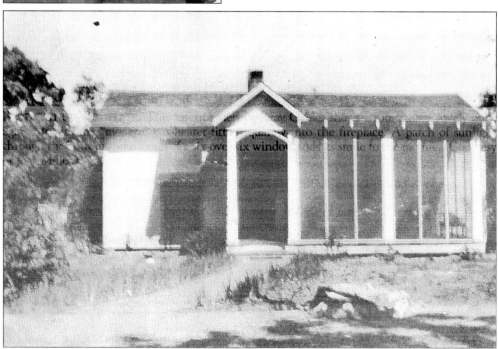

FRONT OF 911 MEMPHIS STREET, HOLLY SPRINGS, 1930s. This home—old but not antebellum—is built on land acquired by Anne Hedderick Reed's ancestors during the Chickasaw Cession of the 1830s. (Courtesy of Anne Reed.)

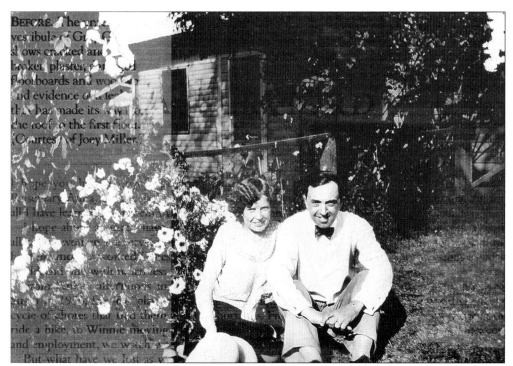

BRUCE BOWERS AND MARY MILLER CHRISTY, 1920s. The couple sits in the back garden of 911 Memphis Street. (Courtesy of Anne Reed.)

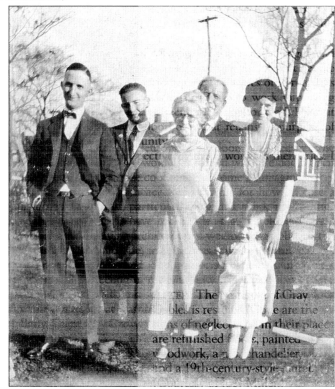

MAMIE BOWERS, ANNE HEDDERICK, AND FRIENDS, 1930s. The Bowers family matriarch, center, poses with family and friends, including young Anne Hedderick, far right front. (Courtesy of Anne Reed.)

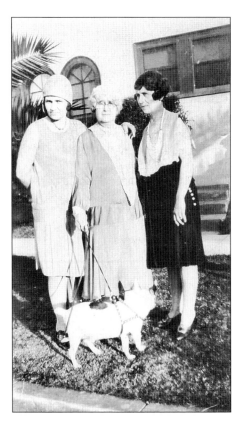

ON VACATION, 1930. Three fashionable Holly Springs ladies are pictured here while visiting a tropical "paradise." At the left is a young woman named Selma at age 19; Mamie Bowers stands in the center; Mamie's sister, Margaret, is on the right; and on a leash and harness is their "pug friend." The quotations are taken from a handwritten note on the back of this photograph. (Courtesy of Anne Reed.)

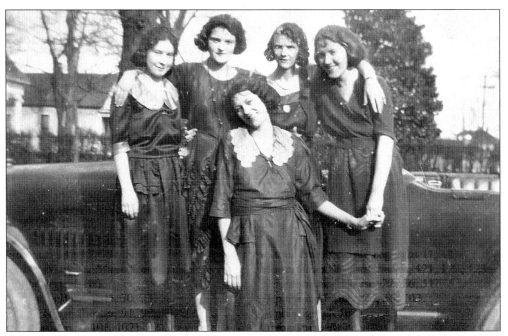

A YOUTHFUL GROUP. Anne Hedderick's school friends are pictured beside a Model T in the late 1930s. (Courtesy of Anne Reed.)

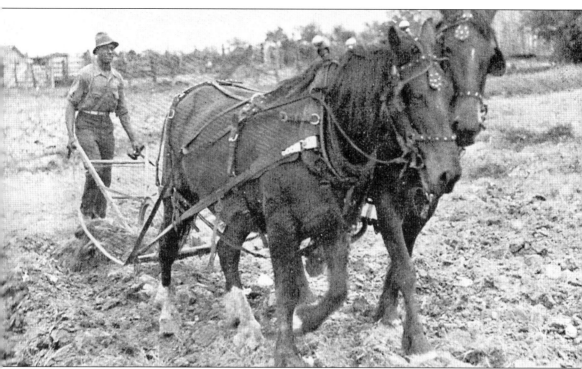

STUDENT PLOWING AT RUST COLLEGE, 1930s. During the harsh Depression years, students earned money toward their education at Rust College by farming or manufacturing. Expertly supervised, male students raised crops that helped feed Rust's student body or were sold for a profit. The land farmed was partly on Rust property and also on land that lay outside of Holly Springs; this land was purchased by Rust president Dr. Lee Marcus McCoy, who spent his personal savings to buy the farmland for $500. (Courtesy of Anita Moore and the Rust College Archives.)

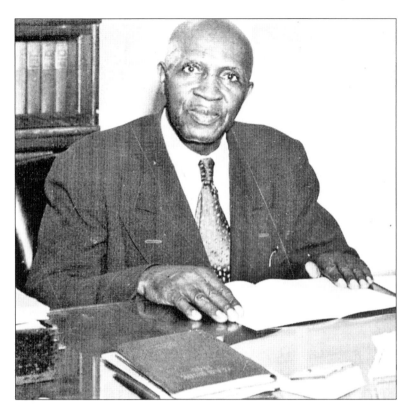

THE REVEREND DR. LEE MARCUS McCOY, 1930s. Dr. McCoy was the second black president of Rust and was the first Rust alumnus to serve as president. He directed Rust from 1924 until his retirement in 1957. Rust's present-day McCoy Administration Building, constructed in the late 1940s, is named in Dr. McCoy's honor. (Courtesy of Anita Moore and the Rust College Archives.)

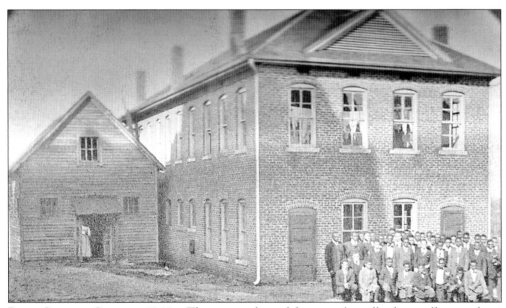

RUST COLLEGE CAMPUS, 1940s. This group, dressed far more formally than college students today, poses behind a now long-gone hall. The structure's use as a laundry is confirmed by the lines of drying clothing visible through the upstairs windows. (Courtesy of Anita Moore and the Rust College Archives.)

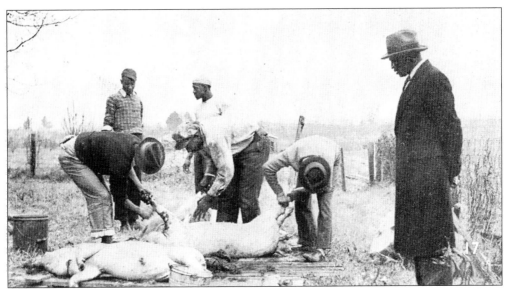

HOG BUTCHERING AT RUST FARM, 1930S. The task of meat preparation was carried out through all of its stages during the Depression years. Meat products were consumed by Rust students of sold at a profit. (Courtesy of Anita Moore and the Rust College Archives.)

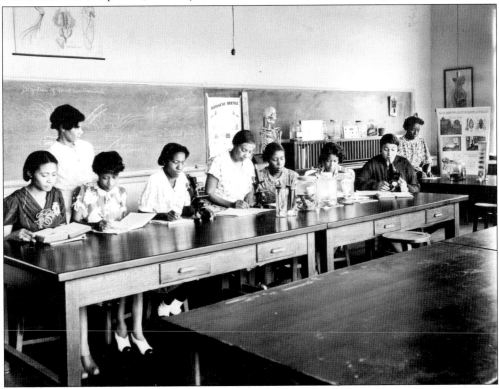

BIOLOGY CLASS AT RUST COLLEGE, 1940S. A state-of-the-art classroom makes for busy and well-informed students, although the skeleton, seen in the background, must have been the subject of numerous pranks. Biology is still a popular major at Rust College. (Courtesy of Anita Moore and the Rust College Archives.)

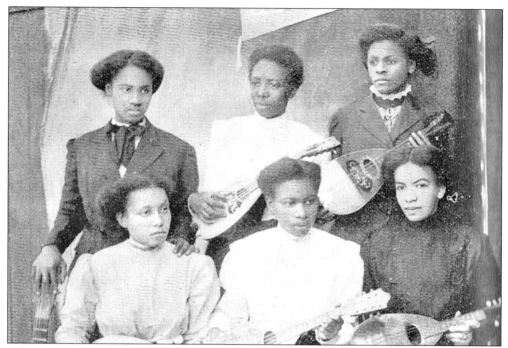

A Rust College Female Musical Group, Early 20th Century. The identities of these young women are unknown, and their music for five mandolins and a guitar can only be imagined. (Courtesy of Anita Moore and the Rust College Archives.)

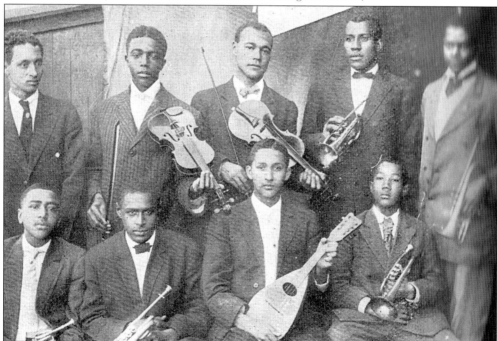

A Rust College Male Musical Group, Early 20th Century. In a memorable image, these nine unidentified gentlemen promise expertise on brass and strings, both strummed and bowed. (Courtesy of Anita Moore and the Rust College Archives.)

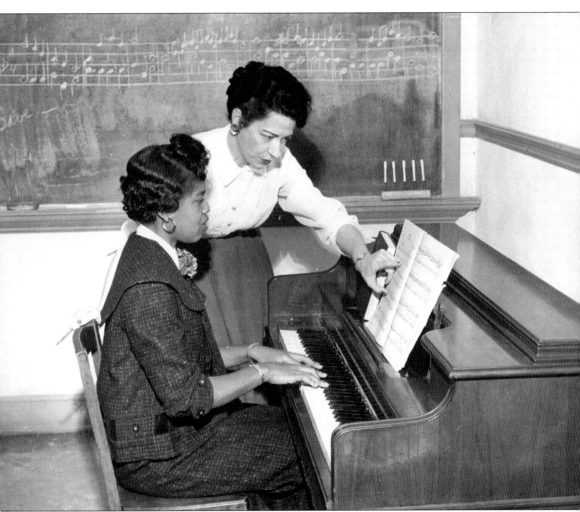

DELORES THIGPEN UNDER THE GUIDANCE OF MRS. O. S. SAINZ, RUST COLLEGE, 1958. The importance of proper posture and hand position is evident in this student's picture-perfect stance. Music majors at Rust still practice piano daily during the school year. (Courtesy of Anita Moore and the Rust College Archives.)

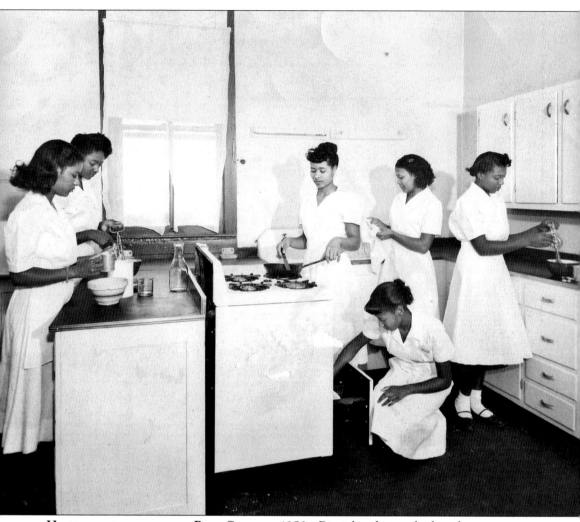

HOME ECONOMICS CLASS AT RUST COLLEGE, 1950S. Disciplined in methods and measurements, these young women pose in their starched white uniforms. Their aluminum measuring cups, crockery mixing bowl, glass milk bottle, and hand mixers are all tokens of bygone days. (Courtesy of Anita Moore and the Rust College Archives.)

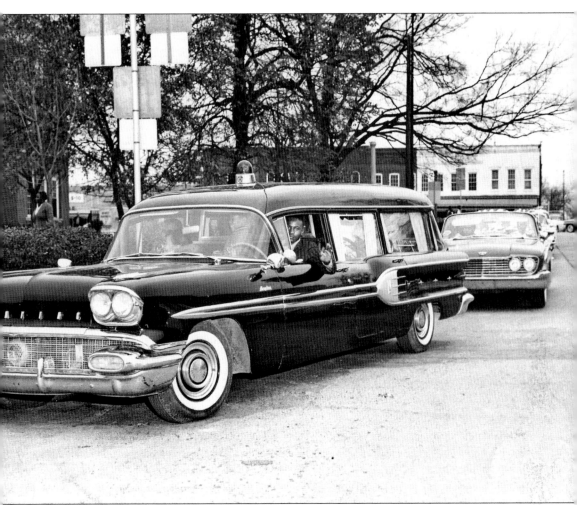

A Funeral Procession through the Square, 1950s. This cortege could have come from Rust College, where funerals are sometimes held today. J. F. Brittenum and Son, the funeral directors in charge of the service pictured here, are still in business on Holly Springs's Memphis Street. Visitors to Holly Springs often remark on the number of funeral directors in this small city; there are four in town, and three are within two blocks of each other. (Courtesy of Anita Moore and the Rust College Archives.)

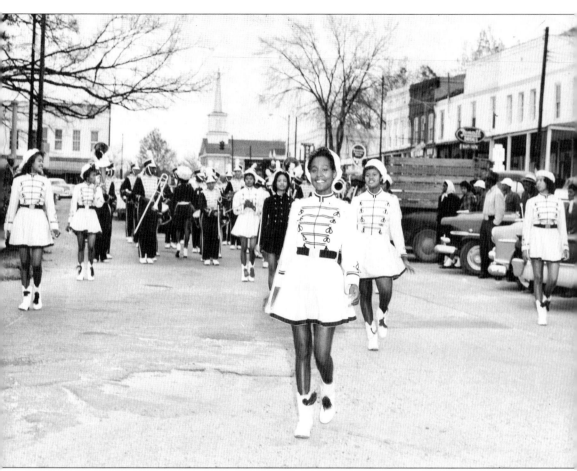

RUST COLLEGE HOMECOMING PARADE, 1960S. The still-popular tradition of parading around Holly Springs's town square is in full swing in this picture. In the center background, the Methodist church can be seen. In the background to the left is the former location of Issac C. Levy's Clothiers; the Levy name is still on the tiles before the front door. On the right stands a block of antebellum store fronts. (Courtesy of Anita Moore and the Rust College Archives.)

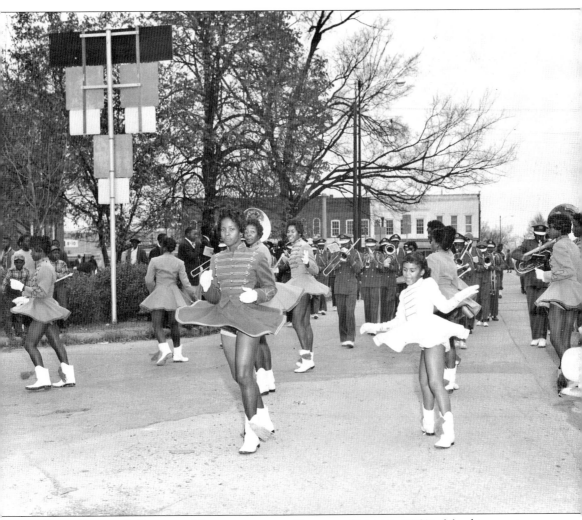

RUST COLLEGE'S BEARCAT MAJORETTES AND BAND ON PARADE, 1960S. Marching west on Van Dorn Avenue, the group pictured here is about to turn to their right to head north up Memphis Street. In the background at left is a corner of the Marshall County Courthouse, which stands in the center of Holly Springs's town square. In the center is a block of antebellum storefronts and offices. Along this row once stood the original Holly Springs Masonic Hall, blown up by Confederate raider Earl Van Dorn and his troops, December 20, 1862. The post-Civil War building that replaced the original Masonic Hall was a three-story structure; its top two floors were destroyed by fire on February 7, 1951. The building now houses Buford's Furniture Store; it is a single-story structure. (Courtesy of Anita Moore and the Rust College Archives.)

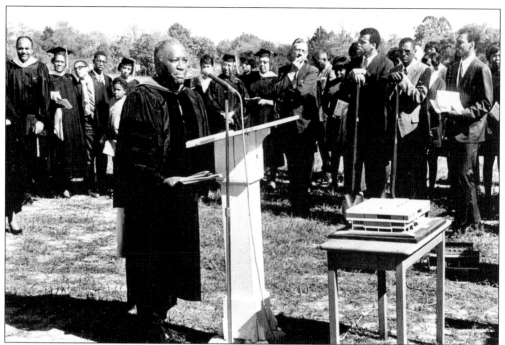

GROUNDBREAKING CEREMONY FOR THE NEW LEONTYNE PRICE LIBRARY, RUST COLLEGE, LATE 1960s. Rust College Board of Trustees president Dr. W. Astor Kirk officiates; a model of the library is on the table before him. (Courtesy of Anita Moore and the Rust College Archives.)

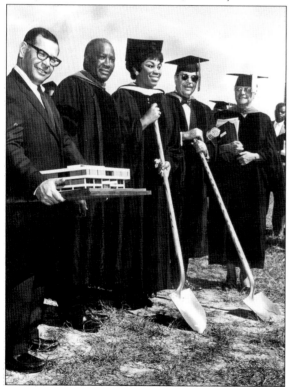

SHOVELS IN HANDS. From left to right are an unidentified member of Rust's Board of Trustees, Dr. W. Astor Kirk, world-famous opera diva Leontyne Price, W. Clement Stone, and Dr. Anna Hedgemann. (Courtesy of Anita Moore and the Rust College Archives.)

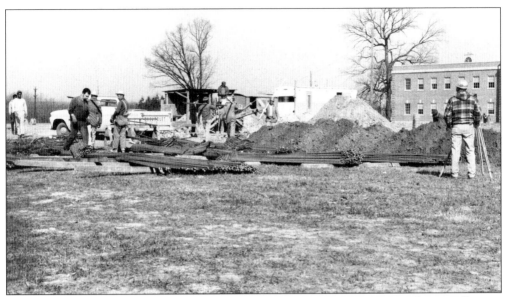

LAYING THE FOUNDATION FOR THE LEONTYNE PRICE LIBRARY, 1969. A dream still in its blueprint stage, Rust's new library is hardly more than a hole in the ground. (Courtesy of Anita Moore and the Rust College Archives.)

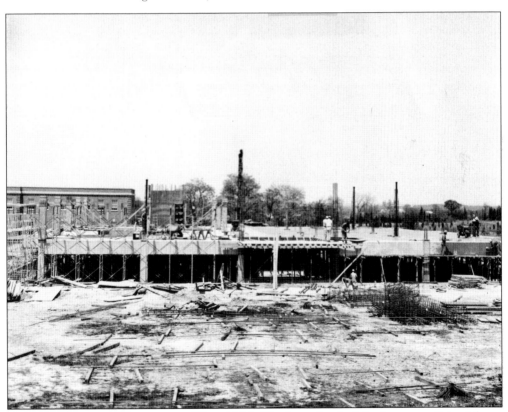

THE NEW LIBRARY WELL UNDER WAY, 1969. The lower level of the Leontyne Price Library takes shape. (Courtesy of Anita Moore and the Rust College Archives.)

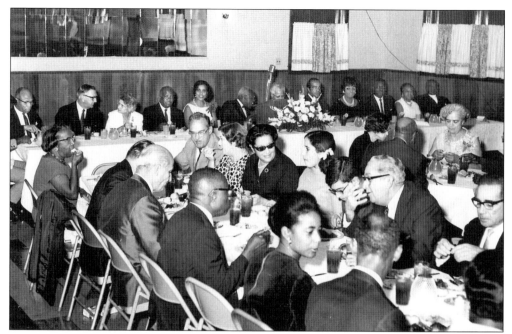

BANQUET HONORING LEONTYNE PRICE, 1969. The new library is nearing completion, and Leontyne Price is thanked for her contributions to Rust College. In her pearls, Price sits at the head table, shown at the rear of this photograph, right corner, fourth from the right. (Courtesy of Anita Moore and the Rust College Archives.)

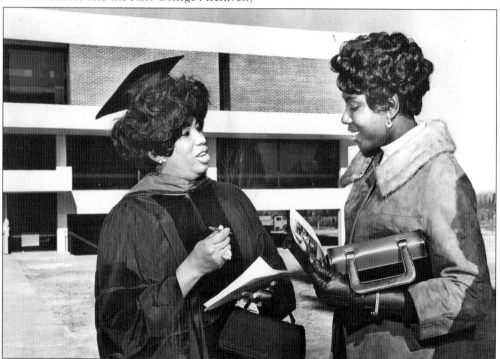

AUTOGRAPHING. Opera star Leontyne Price stops to sign a program for a Rust College student in 1969. (Courtesy of Anita Moore and the Rust College Archives.)

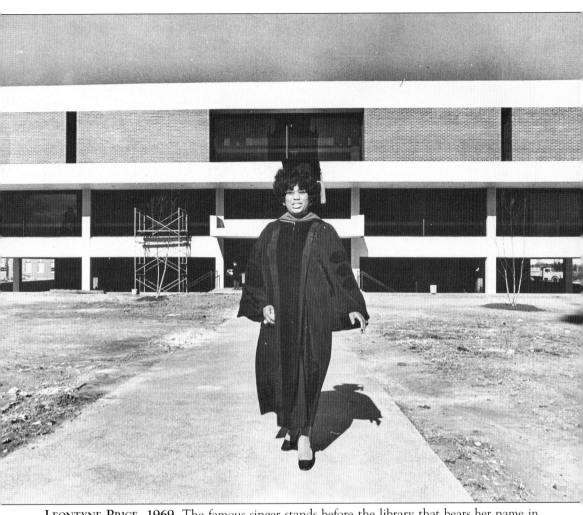

LEONTYNE PRICE, 1969. The famous singer stands before the library that bears her name in academic regalia. (Courtesy of Anita Moore and the Rust College Archives.)

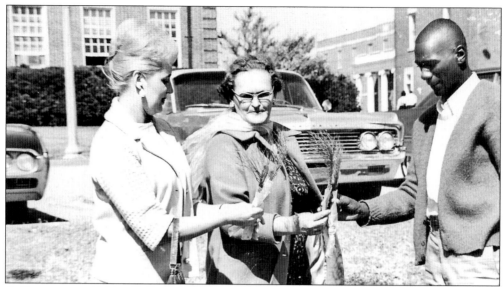

A DONATION, 1960s. Holly Springs clubwomen, most likely members of one of the city's two garden clubs, donate saplings to Rust College. (Courtesy of Anita Moore and the Rust College Archives.)

RUST COLLEGE CAMPUS, 1960s. This is a view from the south side of the campus. At left is the McCoy Administration Building, which is still in use. On the right is The Rust House, built in the 1880s and used as a dormitory in the 1960s. This building was pulled down to make room for the Brown Mass Communications Building, which stands today. The building in the center, Oak View Mansion, is used as offices and is the only 1860s structure still standing on campus. (Courtesy of Anita Moore and the Rust College Archives.)

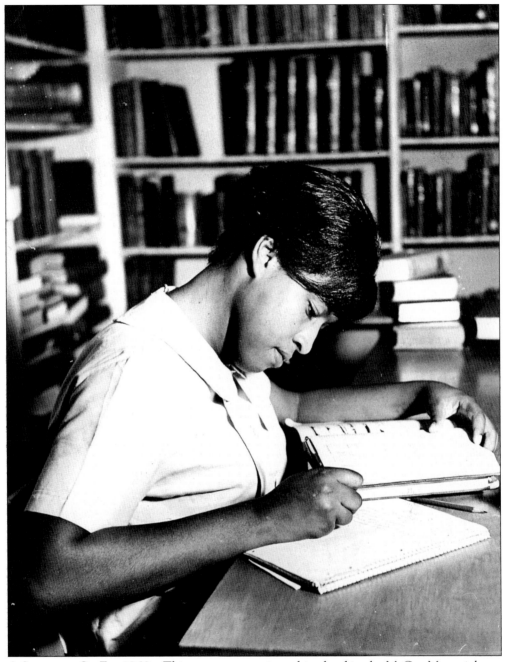

A Studious Co-Ed, 1960s. This young woman is working hard in the MaGee Memorial Library. (Courtesy of Anita Moore and the Rust College Archives.)

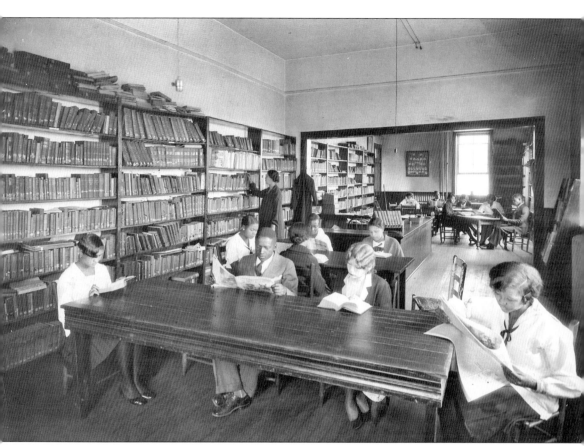

AN INTERIOR VIEW OF THE MAGEE MEMORIAL LIBRARY, 1940s. Taken long before the days of computers and copy machines, this library photograph reminds of taking notes in long hand; searching for title, subject, and author in card catalogues; and seeking the help of the librarian. (Courtesy of Anita Moore and the Rust College Archives.)

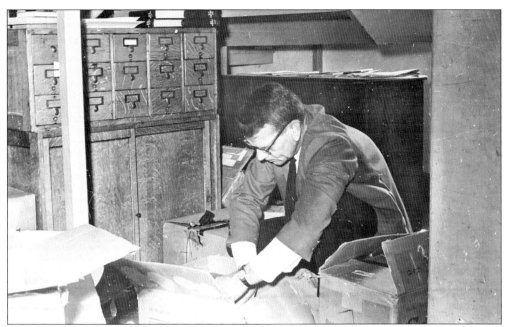

DIGGING FOR KNOWLEDGE, 1960S. Rust College Library staff member Mr. Richardson searches for resources. (Courtesy of Anita Moore and the Rust College Archives.)

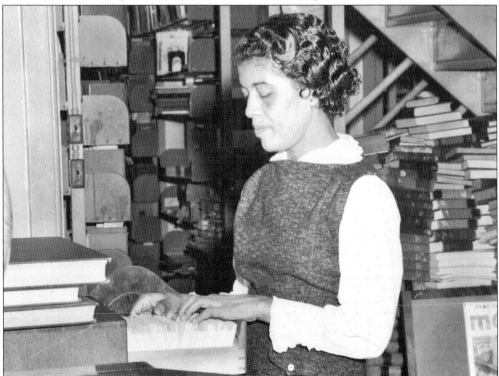

AN OLD-FASHIONED CARD CATALOG, 1960S. "Subject, author, title" was the library standard before the days of computerized holding lists. This student is diligently searching for information in one of those three categories. (Courtesy of Anita Moore and the Rust College Archives.)

MISSISSIPPI INDUSTRIAL COLLEGE, 1970s. This school, founded in 1908, served African American students until it closed in the early 1980s. Still standing across Memphis Street from Rust College, most of the buildings on the old "MI" campus are now derelict. This long vista of lawn continues to separate the former campus from Memphis Street, making the often-overgrown structures appear foreboding. At the north end of the former MI campus, one large hall has been restored and is now headquarters for the Holly Springs Police Department. (Courtesy of Anita Moore and the Rust College Archives.)

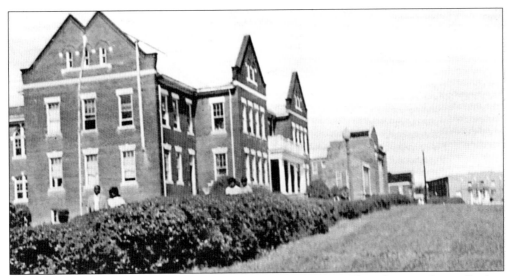

MISSISSIPPI INDUSTRIAL COLLEGE STILL THRIVING, 1970s. This photograph recalls days of prosperity when there was intense athletic competition with Rust College, which stands across Memphis Street from the old MI campus. (Courtesy of Anita Moore and the Rust College Archives.)

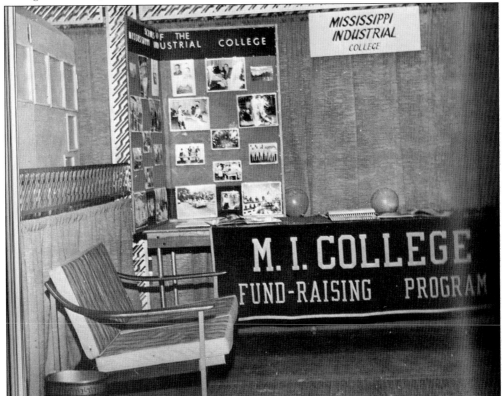

FUNDRAISING IN THE 1970s. The activity shown on the display board in this photograph belies the school's actual situation. Within a dozen years, Mississippi Industrial College would close, and its campus would be vacant. (Courtesy of Anita Moore and the Rust College Archives.)

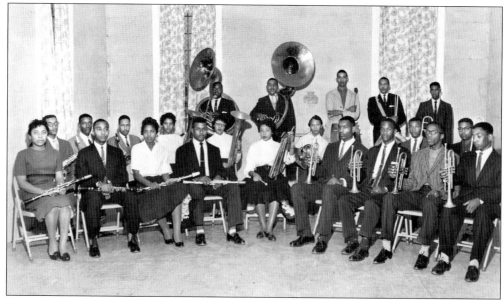

THE RUST COLLEGE BAND, EARLY 1960S. Now under the leadership of Dr. Maurice Weatherall, who also conducts the Corinth Mississippi Symphony Orchestra, Rust's band program has grown to three-times this size. (Courtesy of Anita Moore and the Rust College Archives.)

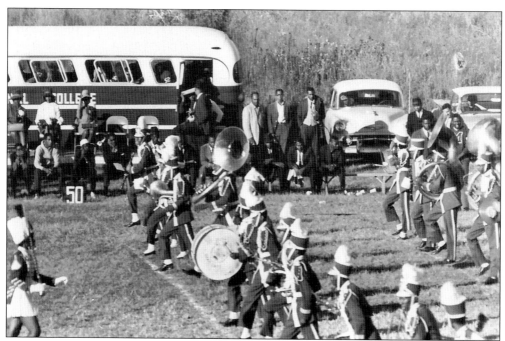

ON THE FIELD, 1960S. Rust College's marching band goes through its paces. Near the 50-yard line, Rust's band marches down the field. The football program at Rust was started in 1926 but was discontinued in the mid-1960s. (Courtesy of Anita Moore, Cynthia Cole, and the Rust College Archives.)

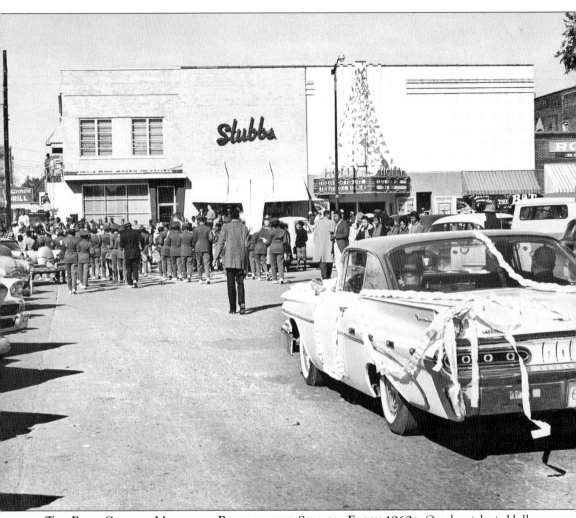

THE RUST COLLEGE MARCHING BAND ON THE SQUARE, EARLY 1960s. On the right is Holly Springs's former movie theater, the Holly, which is no longer in business. Stubbs Department Store has also vanished from the square. (Courtesy of Anita Moore and the Rust College Archives.)

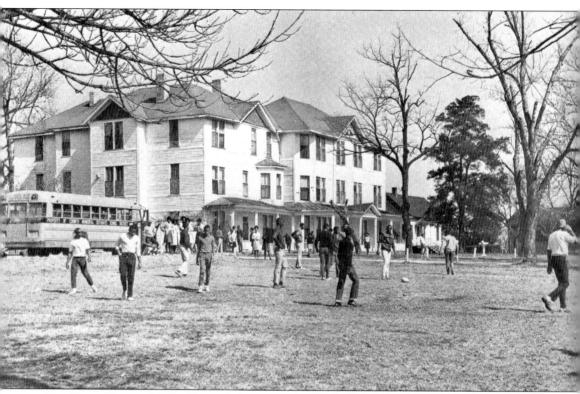

THE RUST HOUSE, 1960s. Formerly known as the Elizabeth L. Rust Home for Girls, this 1884 structure was still in use as a dormitory in the 1960s. Lunchtime sunshine brightens a break from a day's studying. (Courtesy of Anita Moore and the Rust College Archives.)

Four

THE 20TH CENTURY
Mid-Way Onward

The second half of the 20th century saw a number of Holly Springs's 19th-century structures pulled down and replaced during the post–World War II economic boom. No longer were families forced to occupy homes they could not afford to renovate, but in the process of modernization, many antebellum houses were lost.

During this time, Rust College replaced buildings that were outdated, although some structures were destroyed by fires that forever altered the profile of Holly Springs. Overall, however, new construction has done little to shift the shape of the town square, the remaining antebellum homes, and Holly Springs residents' enduring appreciation of their history.

EDWARD HULL "BOSS" CRUMP ON A VISIT TO HOLLY SPRINGS, 1940S. Although he spent most of his time in Memphis, Tennessee, where he was both loved and despised as a political boss, E. H. Crump (center) often visited his native Holly Springs on weekends. (Courtesy of Ben Martin and David Person.)

**CHRIST EPISCOPAL CHURCH RECTORY,
1953.** This home has stood at the corner
of College and Randolph Streets since the
1880s. The rectory is now the new home
of the Reverend Bruce McMillan, pastor of
Christ Episcopal Church, which stands out
of view to the left side of this photograph.
(Courtesy of Anne Reed.)

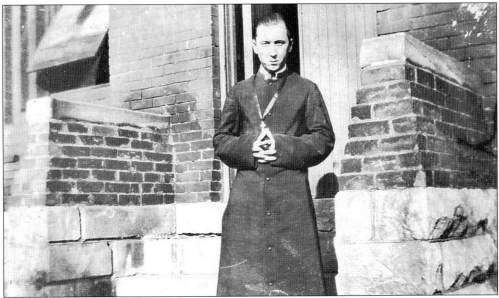

THE REVEREND JOHN BODIMER IN FRONT OF CHRIST EPISCOPAL CHURCH, 1950. Pastor
of Christ Episcopal Church from the late 1940s until 1952, the Reverend Bodimer stands in
morning light perhaps hoping for a breeze to cool his sanctuary in this reminder of days before
air conditioning when even stained-glass windows could be tilted for air circulation. John
Bodimer came to Christ Episcopal as a bachelor when he was around 30 years of age. A popular
minister, he was known for his huge appetite. On November 24, 1952, the Reverend telephoned
his doctor who arrived at the rectory to find his patient dead of a coronary thrombosis. The
pastor's remains were buried at Latrobe, Pennsylvania. John Bodimer was only 34. (Courtesy of
Anne Reed and the Reverend Bruce McMillan.)

Thrilling Prophetic Messages
Where--Court House in Holly Spgs.

SPEAKER—Rev. P. J. Lunati Sr., Bible Expositor–
Post War Coming Events on Bible Prophecy.

Beginning Sunday Night at 8 p. m. five interlocking Bible prophecy messages will be preached.

Sunday Night–Signs of the Times

What time on God's Clock does the Bible tell us we are living in?

Monday Night—When they shall say Peace

Does the Bible teach us that the peace and world organization will bring everlasting peace?

Tuesday Night—War No More

Will the nations beat their swords into plow shares and their spears into pruning hooks, which is a result of the greatest farming program the world has ever seen?

Wednesday Night—Television and Anti-Christ

Does the Bible teach us that television will be completed or perfected when the world dictator, the anti-Christ, will reign?

Thursday Night—King of Kings

Will world kingdoms or the King of Glory bring everlasting peace, and how will God bring it in?

We urge everybody to lay aside everything, as you will have to hear every one of these messages. If you miss one you miss the link in the chain of prophecy.

Rev. P. J. Lunati, Sr.
BIBLE EXPOSITER

THE "THRILLING PROPHETIC MESSAGES" OF THE REVEREND P. J. LUNATI SR. AS ADVERTISED JUNE 1945. The Reverend Lunati was a Holly Springs Assembly of God minister whose serial sermons tackled the complications of post–World War II life and technology in the American South. He also built the hunting lodge that became Lunati Farm and was known for his humanitarian efforts to keep workers employed during the Depression. (Courtesy of Milton Winter.)

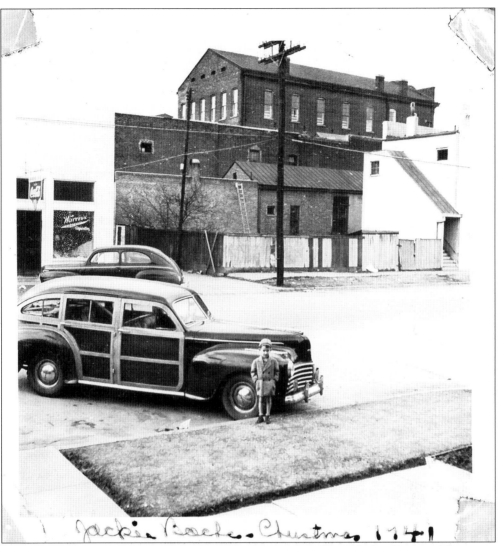

Jackie Bates Christmas 1941

COLLEGE STREET OFF THE SQUARE, CHRISTMAS, 1940s. Young Jackie Bates, a Thompson cousin, was visiting Holly Springs when this photograph was taken. Note the background and the rear of the three-story Masonic Hall, rebuilt in 1870 as a replica of an earlier building destroyed during Earl Van Dorn's 1862 raid. In the early hours of December 20, 1862, Van Dorn lead a band of Confederate raiders into Holly Springs while occupying Federal general Ulysses S. Grant was south of the city. Van Dorn's troopers captured a train load of food, clothing, ammunition, and firearms. They took what they needed, shared the spoils with Holly Springs residents, and destroyed the rest. The raid caused Grant's Vicksburg campaign to be delayed for months. Van Dorn Avenue is named in the Confederate raider's memory. (Courtesy of Claiborne Rowan Thompson.)

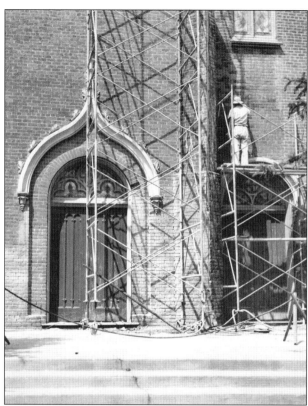

HOLLY SPRINGS PRESBYTERIAN CHURCH UNDERGOING REPAIR, LATE 1940S. This photograph, taken by notable Holly Springs artist Vadah Cochran, shows the extent of the repairs undertaken; the work went on into the early 1950s. (Courtesy of Milton Winter.)

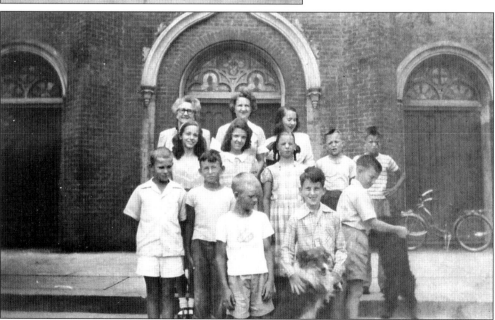

VACATION BIBLE SCHOOL C. 1949 AT THE PRESBYTERIAN CHURCH. Grouped according to age, these children are the oldest to attend vacation Bible school this particular summer. The dog in the front row on the front steps of the church facing Memphis Street adds the flair of summer frivolity to his photograph. (Courtesy of Milton Winter.)

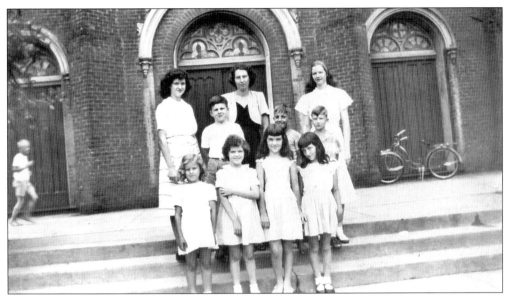

VACATION BIBLE SCHOOL, C. 1949. The younger of the vacation Bible school crowd are short enough to allow a clear view of the Presbyterian church's center front door, which once endured the gunfire of the many skirmishes that took place in Holly Springs during the Civil War. Note the 1940s girls bicycle leaning on its kickstand to the right. (Courtesy of Milton Winter.)

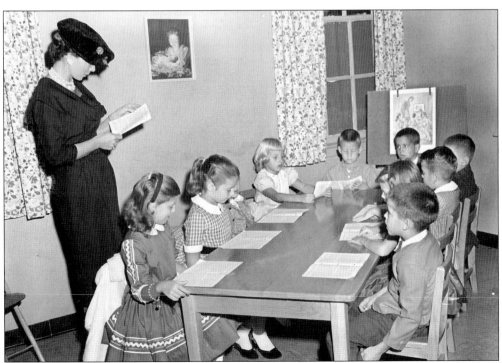

SUNDAY SCHOOL AT FIRST PRESBYTERIAN CHURCH, C. 1957. Mrs. Elton "Bibbi" McIntosh leads her youthful class. From left to right are Leigh Jones, and unknown girl, Emmie Golden, Jimmy Miller, Rufus Warren, two unknown boys, and Taliaferro Warren. (Courtesy of Milton Winter.)

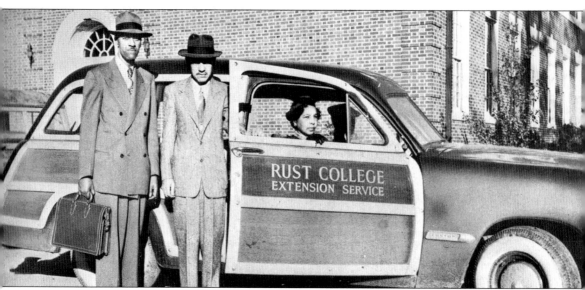

RUST COLLEGE EXTENSION SERVICE PERSONNEL, 1950s. Because teachers often had difficulty furthering their education while working full time, Rust College's Extension Service program for teachers was in full swing by 1935, with 20 centers open in the state of Mississippi. Here four unidentified extension service members set out for the day. In the background is the McCoy Administration Building, still new in the 1950s. (Courtesy of Anita Moore and the Rust College Archives.)

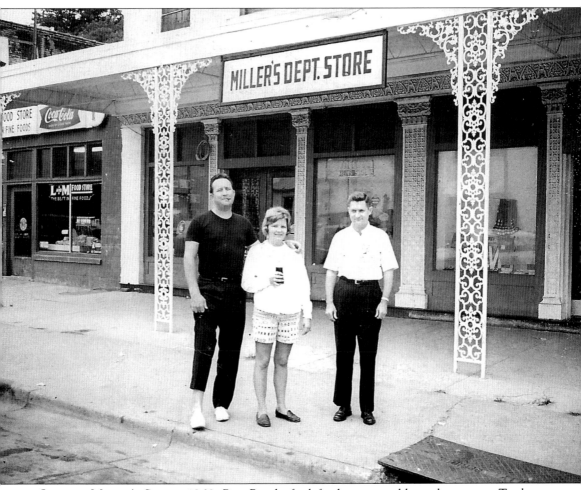

OUTSIDE MILLER'S STORE, 1960. Bert Bonds, far left, shows an ankle to the camera. To the right are Kay Thompson, sporting the loafers so popular at the time, and Graham Miller, whose fathers photograph is on this book's cover. (Courtesy of Claiborne Rowan Thompson.)

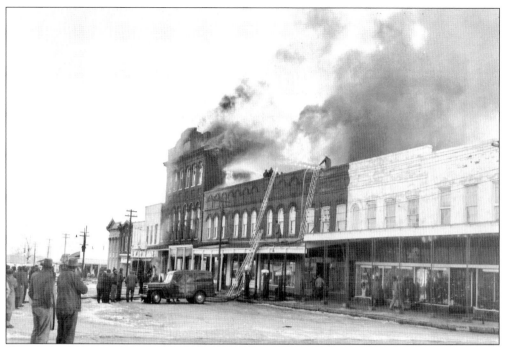

FIRE AT THE OLD MASONIC HALL, FEBRUARY 1951. Like its predecessor, burned during Earl Van Dorn's 1862 raid, the 1879 recreation of the original Masonic Hall catches fire; emergency equipment is on the scene. (Courtesy of O. V. Whittens, *South Reporter*.)

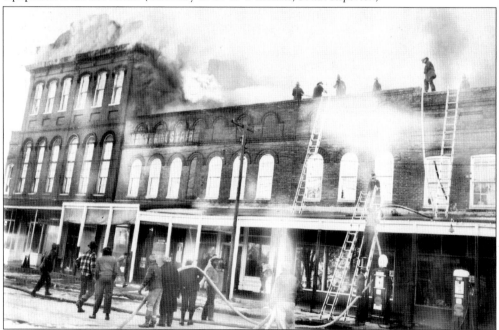

EFFORTS TO CONTAIN THE FIRE, 1951. With contingent structures both north and south of the Masonic Hall clearly in danger, the battle to save property continues. Smoke and steam cloud this photograph. February 7, 1951, was a bitterly cold day. Note the gasoline pumps in the lower right hand corner. (Courtesy of O. V. Whittens, *South Reporter*.)

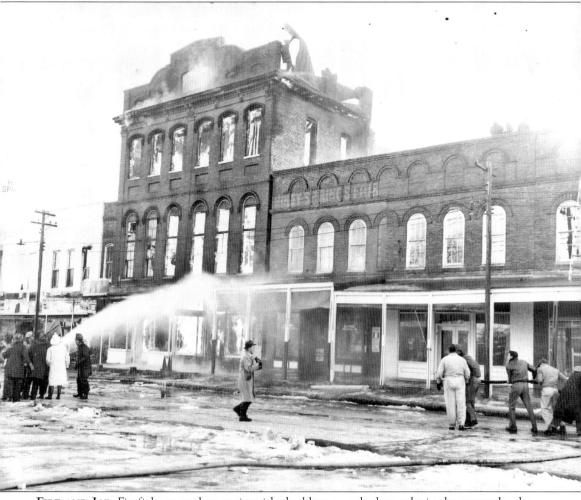

FIRE AND ICE. Firefighters work to extinguish the blaze as onlookers take in the spectacle; the blaze threatens a large segment of the square's east side. From this distance, ice shoveled away from Market Street's northbound land is noticeable. The Old Masonic Hall's room has buckled, and its top two floors are now fully ablaze. (Courtesy of O. V. Whittens, *South Reporter.*)

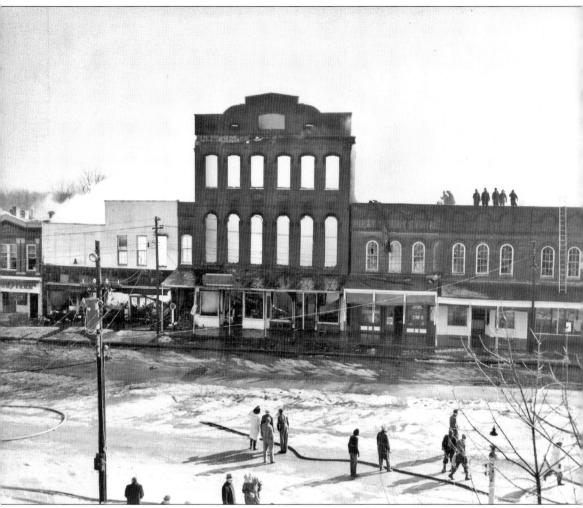

AFTER THE SMOKE CLEARS. Fire hoses stretched across Market Street tell of the struggle to save the square's east quadrant. Only a shell remains of the Old Masonic Hall's upper stories, and smoke now blinds its tall windows. Directly to the left of the ruin is Thompson's Drug Store, still regrouping after Ben Thompson's death in 1950, which will move to the south side of the square due to fire and water damage. The once three-story Masonic Hall will become a one-story building. (Courtesy of O. V. Whittens, *South Reporter.*)

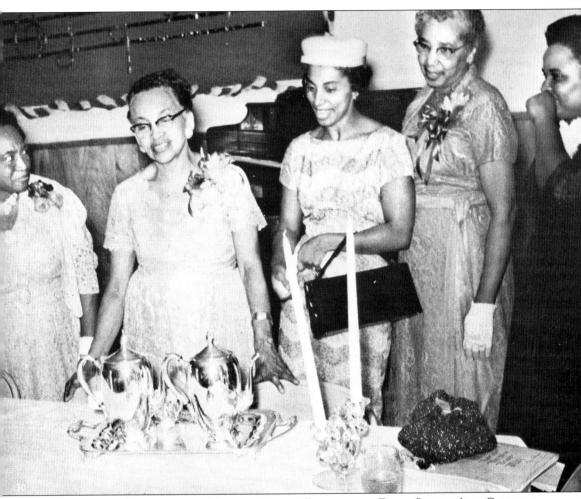

APPRECIATION BANQUET FOR NATALIE DOXEY, FOUNDER OF RUST COLLEGE'S A CAPPELLA CHOIR, 1959. The daughter of former slaves, Natalie Doxey, second from left, attended the American Conservatory of Music in Chicago, where she became fast friends with Marian Anderson. Upon the death of her father in 1929, Doxey returned to Holly Springs, where she founded the world-famous Rust College A Cappella Choir. Today the Rust a Cappella Choir, under the direction of Zebedee Jones, continues to inspire audiences wherever they perform. Here Doxey is awarded a silver tea service. (Courtesy of Anita Moore and the Rust College Archives.)

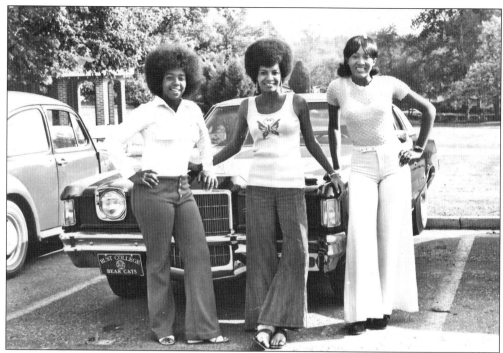

1970s Style. That funky fashion hits the Rust College campus. The gazebo in the background at left allegedly stands on the site of Holly Springs's slave market. (Courtesy of Anita Moore and the Rust College Archives.)

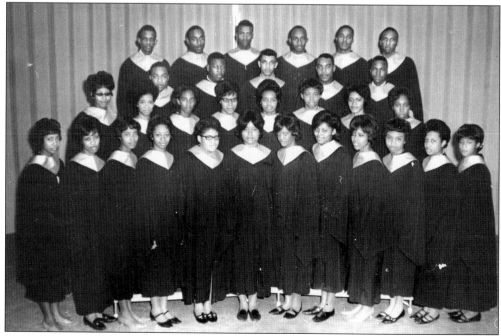

The Rust College A Capella Choir, 1970s. Devoted choir members still rehearse diligently three times a week in Rust College's Doxey Performing Arts Building, named for Natalie Doxey, the choir's founder. (Courtesy of Anita Moore and the Rust College Archives.)

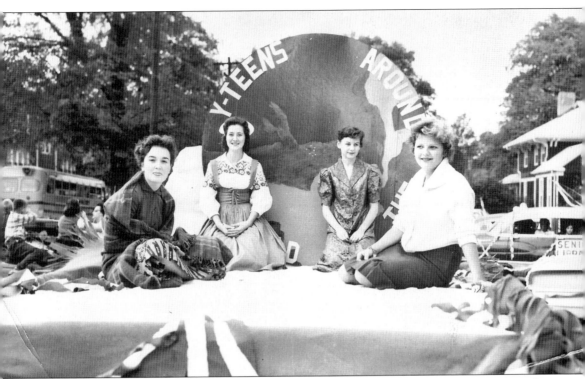

HOLLY SPRINGS HIGH SCHOOL'S "Y-TEENS AROUND THE WORLD," LATE 1950S. Costumed to represent different cultures, four young women from "Holly High" top a float about to parade from Fant Street onto Walthall Avenue. From left to right, Dottie Smith, Ann Fitch, Mary Frances Rather, and Kay Thompson are ready for the occasion. On the far left is the southeast corner of the former Holly Springs High School building that first went up in 1879, then acquired additions through 1909. A new building now occupies the site. On the right is the former home of J. E. Anderson, whose name, inlaid in blue and white tile, still graces the sidewalk on Walthall Avenue's east side. (Courtesy of Claiborne Rowan Thompson.)

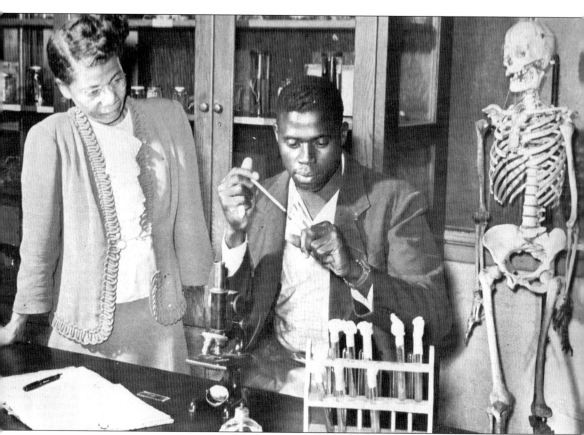

Mary R. Jackson, Associate Professor of Biology at Rust College, 1960s. Professor Jackson was admired for her dedication to science, but she also assisted Rust students in planning parties and creating decorations. In the 1960s, Rust's campus was beautified by the many shrubs and flowers she planted. Professor Jackson retired in 1964. (Courtesy of Anita Moore and the Rust College Archives.)

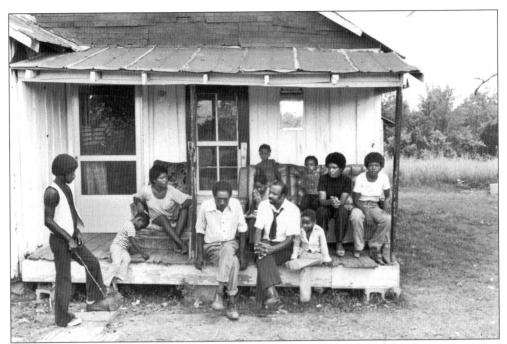

A Gathering of Friends and Folk, Holly Springs, 1970s. This group of unidentified Holly Springs residents offers a glimpse into the sort of low-income housing still seen here. Nothing, however, is more enriching than a porch full of friends and family on a summer day. The mirror hanging on the front exterior wall is said to drive away evil. (Courtesy of Anita Moore and the Rust College Archives.)

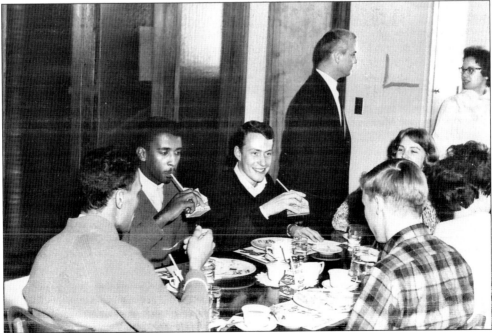

Lunching at Rust College, Late 1960s. A group of visiting students from Michigan eat lunch with Rust College students. (Courtesy of Anita Moore and the Rust College Archives.)

THE REVEREND AND MRS. MARSHALL DELASHMIT, HOLLY SPRINGS, 1980S. Childhood sweethearts, Marshall and Katherine Delashmit raised five children together. Here the Reverend Delashmit is seen standing in the pulpit of Chewalla Assembly of God Church, which he pastored for more than 20 years. (Courtesy of Katherine and Joyce Delashmit.)

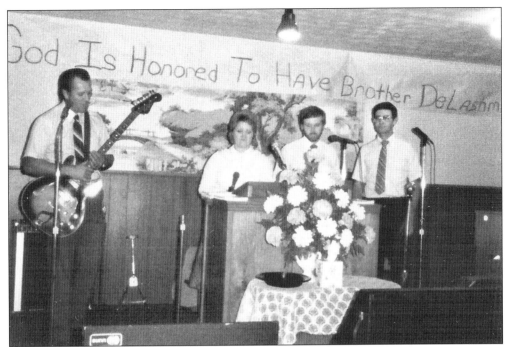

THE DISCIPLES PLAYING FOR PASTOR'S APPRECIATION DAY, 1970S. At Chewalla Assembly of God Church, Pastor's Appreciation Day was grandly celebrated during the ministry of the Reverend Delashmit, who passed away in 2004. He is buried in Hill Crest Cemetery in Holly Springs. (Courtesy of Katherine and Joyce Delashmit.)

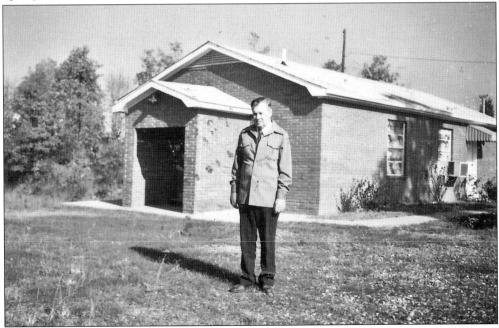

THE REVEREND MARSHALL DELASHMIT, LATE 1980S. The pastor stands outside Chewalla Assembly of God Church, an obviously modern structure. (Courtesy of Katherine and Joyce Delashmit.)

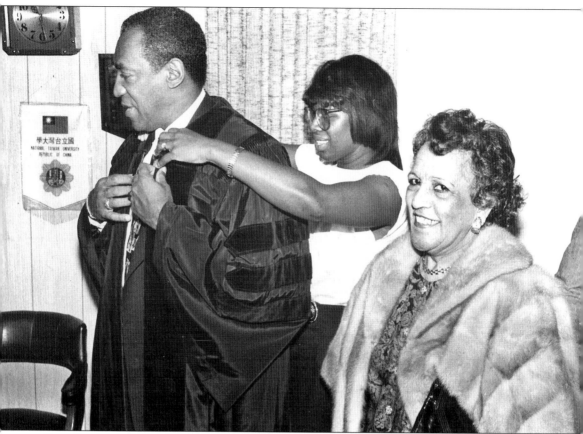

BILL COSBY AT RUST COLLEGE, NOVEMBER 18, 1991. Rust College's first lady, Mrs. William Asbury McMillan (right), and administrator Willa Terry assist Dr. Bill Cosby with his academic regalia. Willa Terry still works in Rust's McCoy Administration Building, which is generally known as "The A Building." (Courtesy of Anita Moore and the Rust College Archives.)

Five

BELLES AND BEAUX OF YESTERDAY AND TODAY

Holly Springs's tour of historic homes, known as the Spring Pilgrimage, is sponsored by the Holly Springs Garden Club. April 2006 will be the city's 68th pilgrimage. Especially then, there is a sense of all who have added their grace and charm to Holly Springs's memories over the decades. Those who lived what we recreate still move among us through old photographs, houses, and stories. Pilgrimage hostesses slip into hoops and dresses of bygone days, learning quickly how to float up a spiral staircase, as did our forebears of the 1860s, 1940s, and 1950s. We welcome all who wish to follow us back in time, if only for one weekend every April.

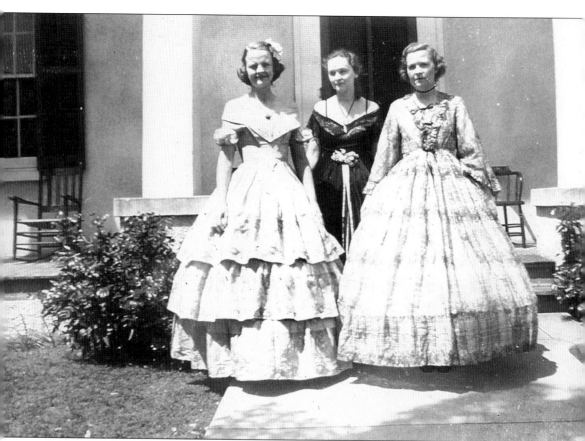

SOUTHERN LADIES OF THE 1940s. In front of Hugh Craft's 1850 Fort-Daniel Place stand three beautifully costumed hostesses. A reminder that time flies, this photograph was taken around 1940 when the "old" Fort-Daniel Place had been standing only about 90 years. The home, sometimes called the Craft-Fort-Daniel Place, stands on the southwest corner of Memphis Street and Gholson Avenue, just south of and across Gholson Avenue from the Presbyterian church. At the time of this photograph, Hugh Craft's descendants had lived in this home for six successive generations. During the Federal occupation of Holly Springs, a Union colonel used this home as his headquarters. From left to right are Margaret Rather, Claiborne Thompson, and Dorothy Seale. (Courtesy of Claiborne Rowan Thompson.)

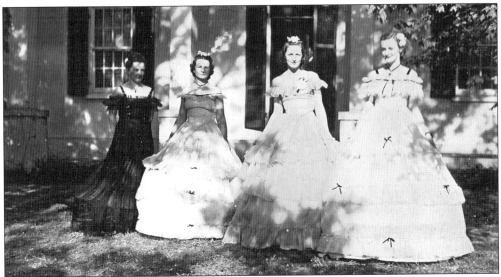

SPRINGTIME SHADOWS, 1940s. Again in front of the Fort-Daniel House stand, from left to right, Claiborne Thompson, Bea Slayden, Helen Thorne, and Eva Louise Henderson. The Holly Springs Pilgrimage was new at the time this photograph was taken. Begun in 1936 by the Holly Springs Garden Club, the Spring Pilgrimage was modeled on the annual Natchez, Mississippi, tour of homes and brought much needed revenue to Holly Springs, which was economically depressed, as was much of the country, in the 1930s. (Courtesy of Claiborne Rowan Thompson.)

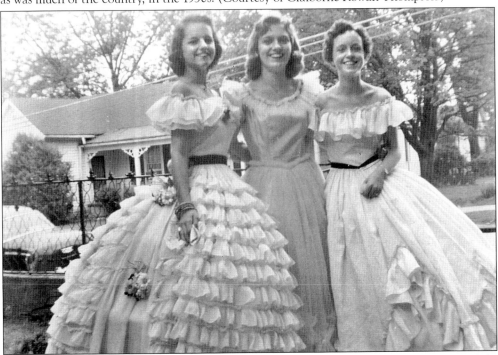

BELLES OF THE 1950s. Despite the backdrop of telephone lines, sidewalks, and an automobile, these three ladies, hairstyles notwithstanding, are ready to take the Fabulous Fifties back a century. On the left is Selwyn Greer with two unidentified companions. (Courtesy of Claiborne Rowan Thompson.)

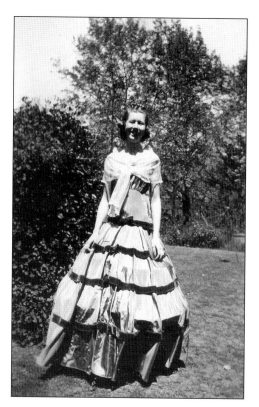

MAE ALICE BOOKER IN HER PILGRIMAGE DRESS, 1940S. A shawl shields Mae Mae from the breeze that breeze presses her pilgrimage gown against the tiers of hoops she wears beneath her skirt. (Courtesy of Claiborne Rowan Thompson.)

CLEMENTINE FONTAINE THOMPSON, AIRLIEWOOD, 1920S. Strolling on the porch of her home, once-U.S. general Ulysses S. Grant's military headquarters in Holly Springs, Thompson wears a late-19th century costume. (Courtesy of Claiborne Rowan Thompson.)

NO RE-ENACTOR—JAMES "J. J." HOUSE DURING THE CIVIL WAR PERIOD. House was a wealthy blockade runner who sold contraband goods to the citizens of Holly Springs at exorbitant rates; thus, he was not a popular man. He purchased Gray Gables from the widow of James Nelson, a clothier on the square. In May 1865, just after the end of the Civil War, Nelson was dragged from his home and forced to his store by a band of marauders—whether Yankee or Rebel is unknown—who wanted clothing. They murdered him in cold blood just after he unlocked the door. Today we study the clothing of such men as J. J. House in order to re-enact the past that still shapes Holly Springs. (Courtesy of Joey Miller.)

AMERICA MCCORKLE, E. H. CRUMP JR.'S GREAT-GRANDMOTHER. This is one of the oldest portraits in Holly Springs. America McCorkle died February 7, 1879, and is buried in Holly Springs's Hill Crest Cemetery. (Courtesy of Edward Rather and Marie Rather McClatchy.)

KATE MCCORKLE NELMS, E. H. "BOSS" CRUMP JR.'S GREAT AUNT. The daughter of America McCorkle, Kate McCorkle, married Charles Nelms, who was killed at the Battle of Shiloh. Charles was the brother of Presley Nelms, who was the father of E. H. Crump Sr. (Courtesy of Edward Rather and Marie Rather McClatchy.)

Margaret Rather in Her Pilgrimage Costume, 1940s. Crape Myrtle blooms behind this Southern belle as she stands in her ball gown. The lawn under her skirts and the hedge behind her have been groomed to perfection for pilgrimage guests. (Courtesy Claiborne Rowan Thompson.)

Anonymous but Gentlemanly, Late 19th or Early 20th Century. An unidentified young man has dressed up for his photographic portrait. (Courtesy of Milton Winter.)

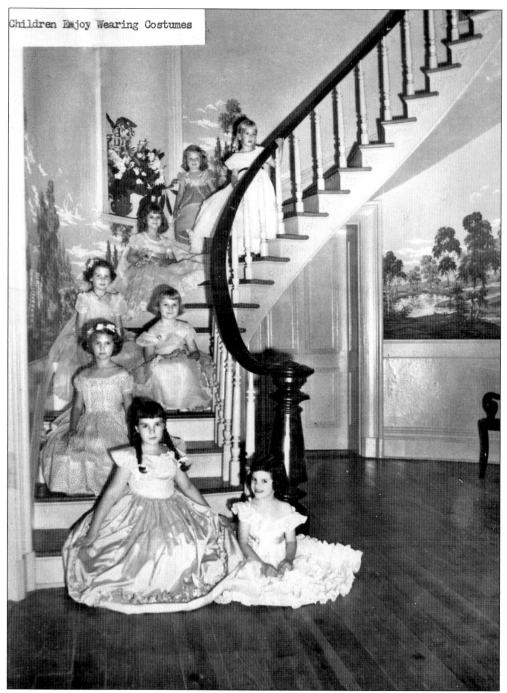

BELLES ON GRAY GABLES' GRAND STAIRCASE, 1950S. Pictured from top to bottom are the daughters of some of Holly Springs's most prominent families: Helen Buchanon, Marie Rather, Elizabeth Sigman, Mary Frances Rather, Caroline Slayden, Bea Hasselman, Martha Phillips, and Marie Sigman. Caroline Slayden, later to become Caroline McCrosky, is one of the people to whom this book is dedicated. (Courtesy of Joey Miller.)

LITTLE BELLES AND A BEAU OF THE LATE 1940s. Matching dolls remind us of the youth of these two lovely girls, despite their hoops and lace. Their gentlemanly escort is even younger. From left to right are Constance A. Lanier, "Little Gus" Smith, and Kay Thompson. (Courtesy of Claiborne Rowan Thompson.)

A YOUNG MEMBER OF THE THOMPSON FAMILY. This is possibly Clementine Fontaine Thompson in the early 20th century. (Courtesy of Claiborne Rowan Thompson.)

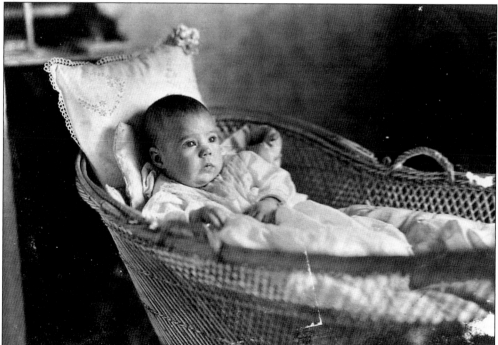

ROCK-A-BYE. This late-19th- or early-20th-century Holly Springs photograph shows us, if not the hand, at least the handle that rocks the cradle. (Courtesy of Anne Reed.)

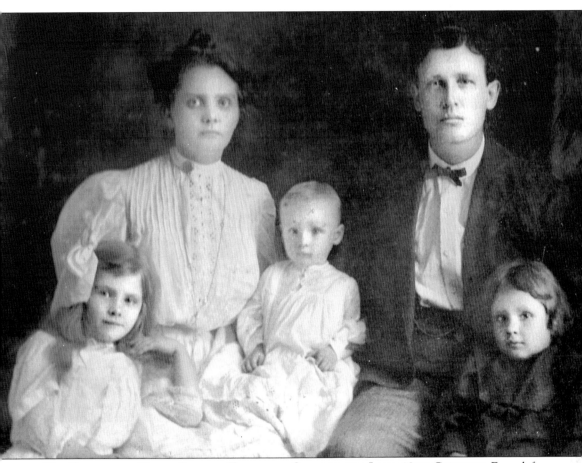

The Prominent Holly Springs Thompson Clan in the Late 19th Century. From left to right are daughter Virginia Thompson, mother Laura Thompson, baby Ben Thompson, father Walter Gray Thompson, and son Lloyd Thompson. This family purchased Airliewood, formerly known as Coxe Place—a large Swiss-style home begun in 1856. Another family purchased the home in the early 21st century. Despite a fire in the attic of the original structure, the new owners have refurbished the grand old home. Airliewood is included in the Holly Springs Spring Pilgrimage of 2006. (Courtesy of Claiborne Rowan Thompson.)

AN EARLY-20TH-CENTURY PHOTOGRAPH. Young Clemmie and her mother, Laura Thompson, pose. The Thompson family later sold Airliewood, which served for a few years as a mental health institution. (Courtesy of Claiborne Rowan Thompson.)

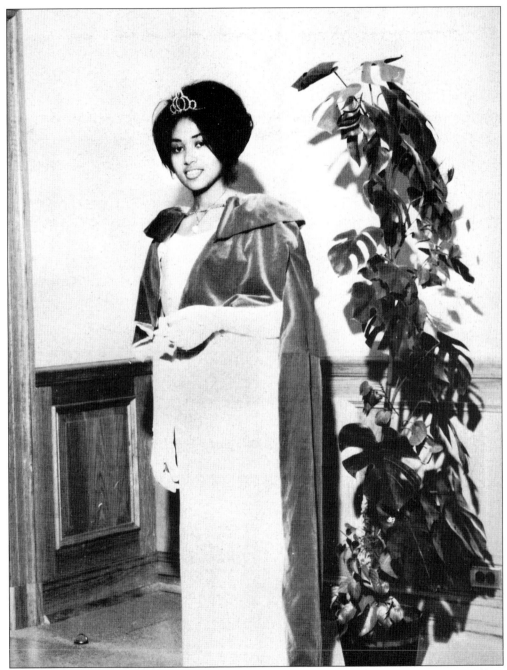

MISS FRESHMAN 1966. Lovely in her velvet cape and satin gown, Norma Welch of Rust College poses gracefully. Her 1960s hairstyle is a classic bouffant. (Courtesy of Anita Moore and the Rust College Archives.)

ANNE HEDDERICK, BELLE WITH DEER, 1937. Anne Hedderick of Holly Springs was 16 at the time this photograph was taken. (Courtesy of Anne Reed.)

"CLAY AND SPOT," C. 1920. Little girl Claiborne Rowan frolics with her dog. Born in 1915, Claiborne Rowan Thompson was a native of Holly Springs. She received her education at the Mississippi Synodical College, where she was a member of the Theta Tau Epsilon sorority. She died Christmas Eve 2005 and is buried at Hill Crest Cemetery beside her husband, Ben Thompson, and their first son, "Little Ben." This photograph's title is taken from a handwritten caption in an old photograph album. (Courtesy of Claiborne Rowan Thompson.)

MOST HANDSOME, MID-1960S. Melvin Robinson strikes a dashing pose at Rust College. Robinson stands outside the McCoy Administration Building. (Courtesy of Anita Moore and the Rust College Archives.)

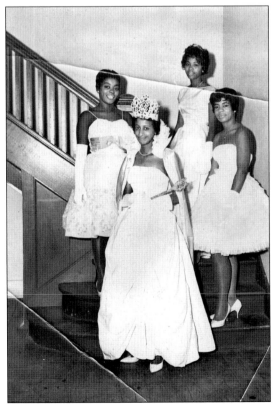

A RUST COLLEGE QUEEN AND HER COURT, 1960S. These unidentified ladies pose in their regal spring finery—a reminder that with high fashion, what comes around goes around. (Courtesy of Anita Moore and the Rust College Archives.)

CLASSIC BEAUTY MISS RUST 1966.
Ann Bush, the "First Lady of the
Student Body," graduated with
an English major at Rust College.
(Courtesy of Anita Moore and the
Rust College Archives.)

**GRANDPARENTS OF THE REVEREND
MARSHALL DELASHMIT, 1920S.**
Dressed in their summer whites, this
family portrait includes aunts, uncles,
and Marshall Delashmit's brother
Woodrow Delashmit, who, according
to his great niece Joyce Delashmit,
"talked so slow, he died in the middle
of a sentence." Woodrow Delashmit's
son, Boyce, also lives in the Holly
Springs area. (Courtesy of Katherine
and Joyce Delashmit.)

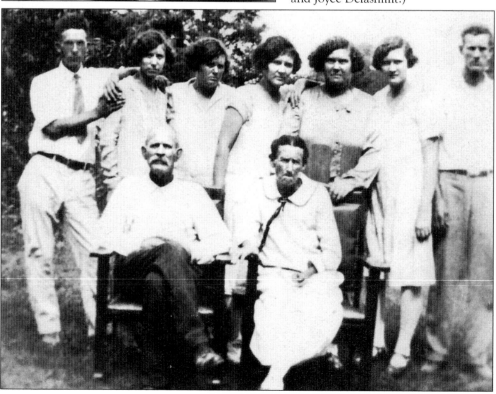

YOUNGSTER BRUCE REED, 1960S. A quizzical expression denotes a deep thinker in this photograph of a future Holly Springs computer guru. His mother, Anne Hedderick Reed, still lives in the Holly Springs home her family built on the plot of land their ancestors purchased during the Chickasaw Cession of the 1830s. (Courtesy of Anne Reed.)

THE HEIGHT OF YOUTHFUL FASHION, 1940S. Little Ben Thompson and an unidentified young lady share a spring afternoon romp on the square Their shadows denote a spring afternoon. (Courtesy of Claiborne Rowan Thompson.)

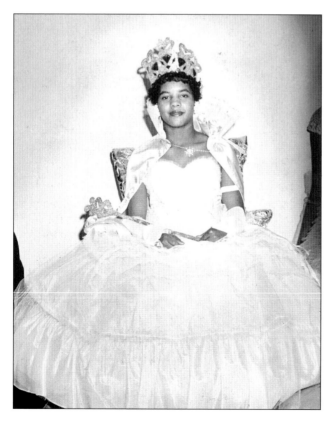

A QUEEN INDEED, 1960S. This lovely but unidentified young woman makes a memorable picture of Rust College "royalty." (Courtesy of Anita Moore and the Rust College Archives.)

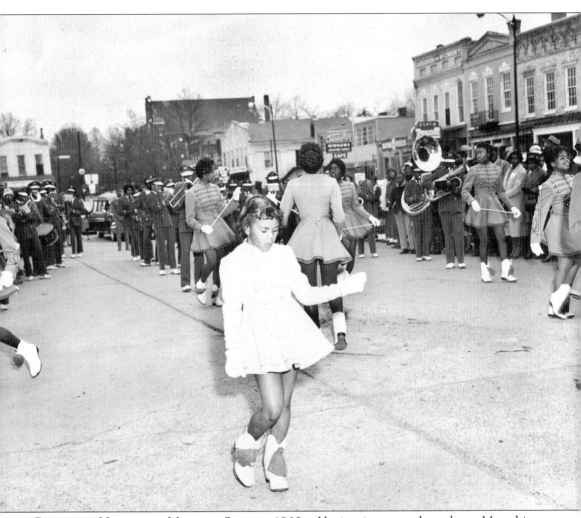

PRANCING NORTH ON MEMPHIS STREET, 1960S. Having just turned north on Memphis Street from Von Dorn Avenue, a young majorette adds her charm to a Rust College parade. In the upper-left background is the last building in a block of antebellum storefronts and offices. The top story is currently a private residence. The tall steeply roofed structure in the center background is the north side of First Presbyterian Church, its remaining bell tower discernible. The white building to he right of the church was—and still is—Miller's Store. Another row of antebellum buildings complete the background at right. (Courtesy of Anita Moore and the Rust College Archives.)

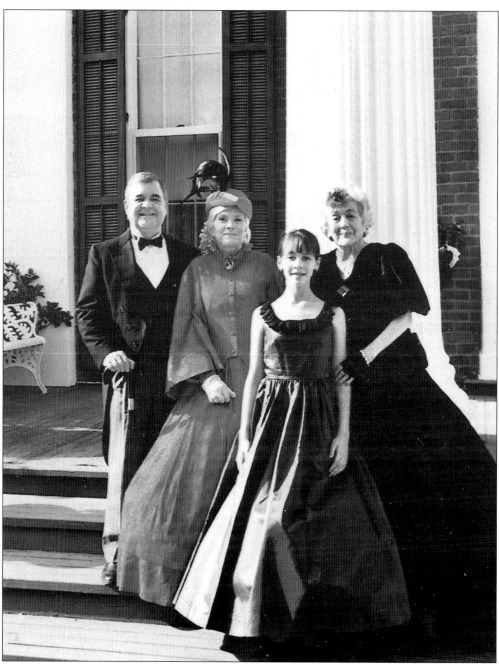

POSING AT HOLLY SPRINGS'S WALTER PLACE. In antebellum costumes and from left to right, Jack Werne, Betty Werne, Tara Moore, and Ruth Shipp add a touch of real life to this grand mansion that has served as a home to Union general Ulysses S. Grant and as a yellow fever hospital in 1878. That year, Harrey Washington Walter, the home's builder, contracted yellow fever, as did three of his sons. All four Walters died of the disease in this house. Because Walter Place is built on slightly elevated ground, the Walter family believed the fever would not reach them. The Walters are buried in Holy Springs's Hill Crest Cemetery. (Courtesy of Jack and Betty Werne.)

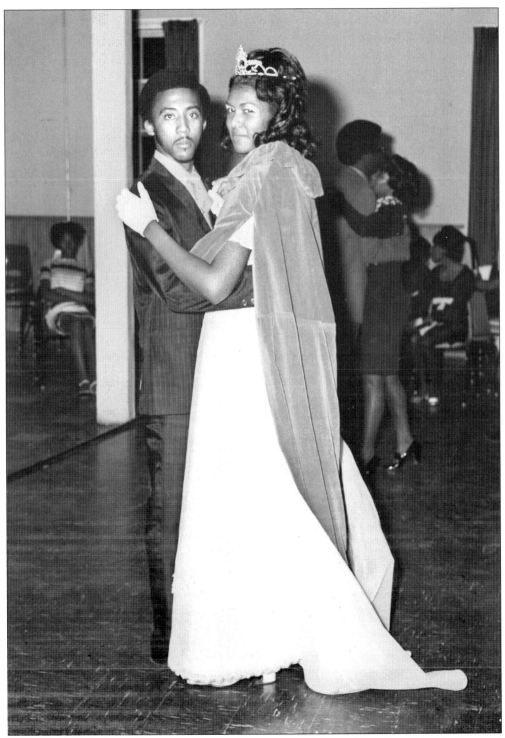

A Charismatic Rust College Couple. Dancing together are Miss Rust Belva Belfour and Willie Burchfield, president of the student government association for the 1969–1970 academic year. (Courtesy of Anita Moore and the Rust College Archives.)

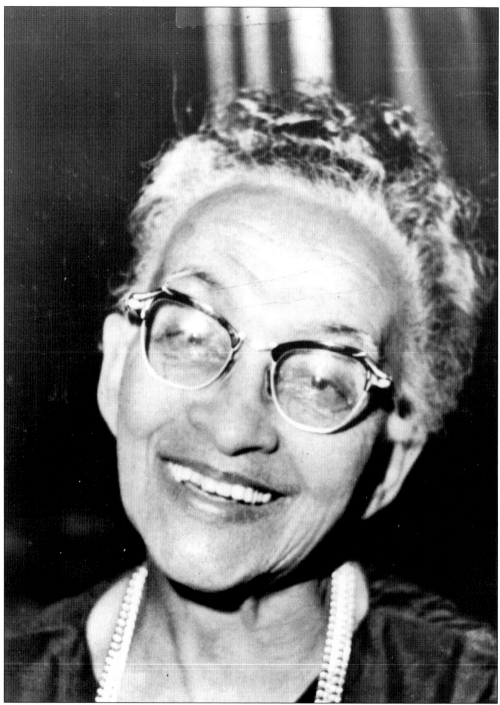

NATALIE DOXEY, FOREVER LOVELY. The generous spirit and outstanding talent of Natalie Doxey, for whom Rust College's Doxey Performing Arts Building is named, will always grace Rust College's campus. Founder of Rust's famous A Capella Choir, Doxey brought the enduring gift of song to Holly Springs, Mississippi. The A Capella Choir performs regularly at Rust and all over the United States. (Courtesy of Anita Moore and the Rust College Archives.)

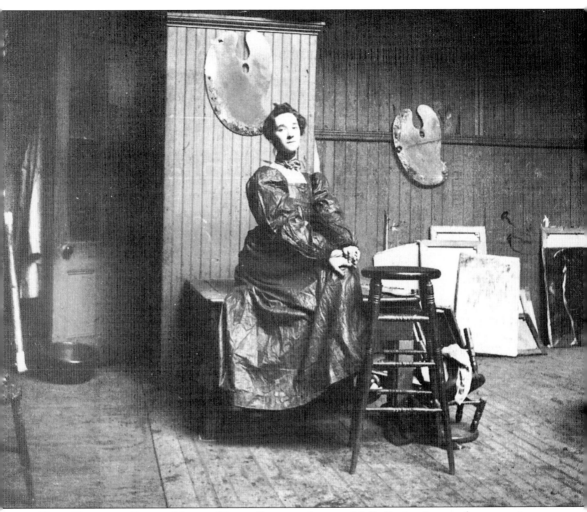

KATE FREEMAN CLARK, NOTED HOLLY SPRINGS ARTIST. Holly Springs's most famous artist, Kate Freeman Clark (1874–1957) studied art in Memphis, Tennessee, then left the South for New York in 1894, where she continued her studies at the Art Student League under American impressionist painter William Merritt Chase. When Chase founded his own New York school, Clark left the Art Student League to continue her work with Chase. It was during this phase of her training that Clark was the most contented and creative. However, Clark ceased painting altogether in 1924. She returned to her antebellum home (now called Walthall Place) in Holly Springs, where she died at age 81, leaving her entire body of work to the city. (Courtesy of the Marshall County Library's Special Collections and Bea Green, curator of the Kate Freeman Clark Art Gallery.)

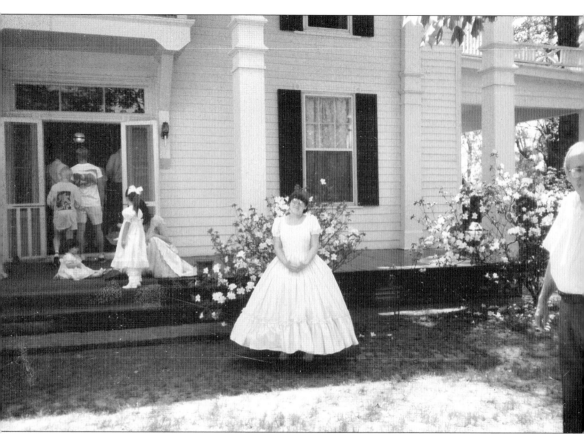

BRIDGING CENTURIES, 1980s. Against a backdrop of blooming azaleas and antebellum columns, Laura Ashley Wheeler (center) stands as hostess at Holly Springs's 1850s Greenwood house, adding loveliness to an already beautiful busy Spring Pilgrimage day. Her pilgrimage gown, and those of the children on the steps at the photograph's left, creates a contrast to the modern warm-weather clothing of guests taking the tour of Holly Springs homes. (Courtesy of Claiborne Rowan Thompson.)